Central Florida's
Most Notorious
Gangsters

CENTRAL FLORIDA'S
MOST NOTORIOUS
GANGSTERS

ALVA HUNT AND HUGH GANT

SAMUEL PARISH

Charleston London

History
PRESS

Published by The History Press
Charleston, SC 29403
www.historypress.net

First published 2008

Manufactured in the United Kingdom

ISBN 978.1.59629.414.1

Library of Congress Cataloging-in-Publication Data

Parish, Samuel.
Central Florida's most notorious gangsters : Alva Hunt and Hugh Gant /
Samuel Parish.
p. cm.
Includes bibliographical references.
ISBN-13: 978-1-59629-414-1 (alk. paper)
1. Hunt, Alva Dewey. 2. Gant, Hugh Archer, b. 1900. 3.
Gangsters--Florida--Biography. 4. Organized crime--Florida--Biography. I.
Hunt, Alva Dewey. II. Gant, Hugh Archer, b. 1900. III. Title.
HV6785.P37 2007
364.1092'2759--dc22
[B]
 2007044280

Contents

Overview

S umter County produced two gangsters who fit into the Roaring Twenties' criminal pantheon with Al Capone, Pretty Boy Floyd, the Barkers, John Dillinger and Bonnie and Clyde Barrow. There were, however, significant differences between Sumter County, Florida's gangsters and those of the Midwest corridor of crime.

While most of the criminals of the late 1920s and 1930s centered their activities in the American Midwest, from where most of them hailed, Alva Dewey Hunt and Hugh Archer Gant focused mostly on their home state of Florida. More precisely they focused on Florida using Sumter and surrounding counties as their headquarters. Additionally, unlike those well-known gangsters Hunt and Gant resorted to less violence and never killed anyone during the commission of a crime.

Gant was a lifelong resident of Sumter County. Fittingly he lived in an area near Webster called Gant Lake, settled by his ancestors during the county's founding. Hunt probably moved to Sumter County with his family at a very young age, settling in Bushnell, where H.D. Hunt, the family patriarch, became an active and successful member of the community.

Gant and Hunt were united by common threads. The most direct was Hunt's early marriage to Gant's sister, Katherine. Both young men were also enthusiasts of the recently popularized automobile with Hunt being the more mechanically inclined. Finally, and probably most importantly, was the link that ran throughout the state of Florida and the rest of the country—the Great Depression. Many causes for the rise in Depression-era criminality have been offered. Weakened economic conditions, escalating farm foreclosures and a general despair guided men toward criminal pursuits, men who otherwise might not have been drawn into them.

Evidence of the marriage that united Hunt and Gant into a Depression-era crime family.

Both served in World War I and returned changed. What they saw during their service probably had a profound impact on them, and like many who survived the experience, they may have internalized negative aspects of violence. Yet despite all these projections, there is no solid evidence to suggest why Hunt and Gant got into crime, but timing certainly factored into their decision. They matured into their early twenties as the roar of the 1920s lessened to a whisper and then faded away.

Although 1929 marked a peak of prosperity in the United States, four years later the Depression had reached its low point. According to Robert McElvaine's *The Great Depression*, unemployment skyrocketed from just over 3 percent to nearly one-quarter of the working population. A lack of opportunity may have played a role in Hunt and Gant's choice of vocation. The obvious choice of farming was prohibitive because land was not easy to acquire and "conditions were particularly bad for farmers, who were now in the second decade of their depression" in Florida.

Like many others Hunt and Gant began with small steps. The arrest of Gant in Orlando for public intoxication was his first recorded legal problem. At some point soon after both boys moved into an automobile fencing

operation, taking stolen parts for rework and illegal sale, for which they were arrested once in Sumter County. They progressed from fencing when they began to physically steal and alter automobiles for resale and parts distribution. Presumably they were able to make more money stealing and altering than simply fencing. At one point the Hunt-Gant automobile theft operation was one of the largest and most prolific in the state. Their names became associated with car thefts from the Georgia border south to Miami and from the southwest coast north to Tallahassee. During that reign each was arrested several times. Pardons, legal mistakes, successful appeals and jail escapes freed them to continue car thievery.

A hiatus followed the 1933 store burglary when Gant's older brother, and reputed gang leader to that point, was gunned down. Two unidentified cohorts were with Riley Gant and successfully escaped. Hunt and Hugh Gant were probably the two accomplices.

With a background in car thievery and automobile mechanics and the ending of their car theft ring Hunt and Gant stepped up to a new level of crime—bank robbery. Their background in auto thievery played a pivotal and prominent role in the gang's escapes after bank heists. They developed a modus operandi that quickly evolved into a successful one. The pattern involved the theft of a vehicle, usually a sedan and typically about two or three weeks before the bank job, and concluded with taking a nearby residence in order to case the bank target. That mode of operation was typical among most successful bank robbery combines. At first they "hit" small banks and were rewarded with equally small hauls. As they progressed in skill and increased in desires and confidence the takes became more rewarding and the bank jobs more brazen.

Their daytime robbery in Ybor City, a Tampa suburb, resulted in a $26,000 take and fostered a cry that went out across Florida in the press and by word of mouth. "Get Gant" became the phrase and Hugh Gant became the focus when Florida crimes were brilliantly planned and difficult to solve.

The criminal combine, known as Hunt-Gant during their automobile operation, morphed into the Gant Gang. Several variants followed but what resulted was Gant being perceived as the chief bad man and the gang's leader in title and brashness. In the end, the combine, by any name, was responsible for more than a handful of bank robberies, numerous post office jobs, an assault and robbery-related kidnappings, and according to accusations, a wide array of other crimes. Although they were never convicted for a murder in Kentucky, a robbery of the Seaboard Air Line Railroad company or safe robberies in Atlanta, Georgia, and other points throughout the South, these crimes were attributed to them.

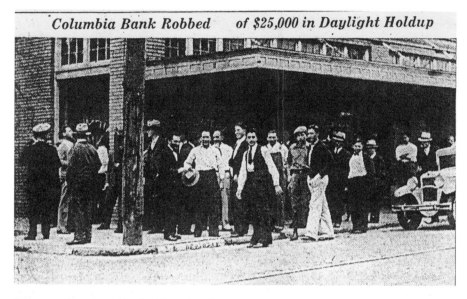

Patrons gathered outside the Columbia Bank in Ybor City after Gant-Hunt and three accomplices brazenly committed the daylight robbery. (*Tampa Times*, March 3, 1936)

Their misadventures included a few escapes from jails and incarcerations at the Raiford State Prison in Florida and United States penitentiaries in Atlanta, Alcatraz and Leavenworth, as well as blazing gun battles during escapes from banks. Ultimately, after Gant and Hunt were convicted for the robbery of two banks "backed" by the Federal Deposit Insurance Corporation, one in Florida and the other in Foley, Alabama, Gant's reputation garnered him a stint at Alcatraz. Due to two previous escapes Gant was considered a serious escape risk. He stayed on Alcatraz, known informally as the Rock, for nine years before being transferred to Leavenworth, Kansas. While in Alcatraz Gant may have mixed with other notable gangsters such as AZ-85 Alphonse Capone, AZ-117 George "Machine Gun Kelly" Barnes, AZ-137 Albert Bates (incarcerated for the Urschel kidnapping), AZ-139 Harvey Bailey (renowned bank robber and possible participant in the Union Station massacre), AZ-297 Harry Sawyer (participant in some of the Barker crimes and the Bremer kidnapping), AZ-307 Edward Bentz (world-class bank robber and caser, possible conspirator in the Urschel kidnapping and an ally of Machine Gun Kelly) and AZ-325 Alvin Karpis (the last of the well-known "public enemies" to be taken).

Less well-known prisoners at Alcatraz while Gant served his time included members of George "Bugs" Moran's Gang, the Purple Gang, Barker-Karpis Gang, Chicago underworld confederates, a Bonnie and

Clyde associate and an array of rapists, murderers and army malcontents. The Birdman of Alcatraz, Robert Stroud, was kept under wraps in solitary while Gant was there. Stroud, known for his well-chronicled and highly praised scientific research on birds, completed his work during an earlier stay at Leavenworth.

Hunt was spared serving time on the Rock, instead spending the totality of his sentence in Atlanta. Gant was finally transferred to Leavenworth and then near the end of his term to Tallahassee. Time took a toll on both men with Gant experiencing vision loss and various aches and pains and Hunt developing Parkinson's disease. Both lived long lives and returned as free men to Sumter County, with Gant making his way back after a stay in Texas. Both reentered society and were buried in Sumter County.

The long, adventurous circle took the men from Florida across Georgia, Alabama, Louisiana and Texas. Hunt may have spent time as far west as Los Angeles, California, operating a gasoline station, while Gant was known to have spent time in Tennessee. There is evidence to suggest that Hunt may have gone as far north as Michigan and that both men went underground in the famous bandit town of Hot Springs, Arkansas.

Their story is an adventure that creates a romantic, historical perspective common to others from the gangster era. Inexplicable gaps leave questions as to other activities and liaisons that could lend to the romance or paint them in a different light. But the romanticism needs to be kept in a proper perspective. Hunt became a businessman, owning two service stations, and Gant found work in the county. They committed crimes, were shot at, escaped prisons, stole vehicles, may have been involved in a knifing and were accused of arson and a murder. They were gangsters in the truest sense. Accomplices participated intermittently but Hunt and Gant were constants. Perhaps the aging process rehabilitated them, the times changed without them or maybe their time behind bars softened rough edges.

The Main Participants

On May 18, 1917, President Woodrow Wilson signed the draft into law leading America into World War I. Less than one month later, Wilson declared that anyone failing to register would be arrested and face one year in jail. Newspaper reports cited arrests of people fleeing the country to avoid serving. Conversely, on June 5, the first day of registrations, ten million men reported.

Among those would-be soldiers who answered the call to serve their country were Hugh Archer Gant, born January 2, 1900 in Webster, Florida, and Alva Dewey Hunt. Gant answered the call by enlisting on August 20, 1917, at Richmond, Virginia. He served in the navy aboard the USS *George Washington* and later received an honorable discharge at Hoboken, New Jersey, serving through November 26, 1919. The *George Washington* had an eventful history. It was originally a German vessel before it was seized by the Allies and converted into a naval transport. Gant was aboard when the *Washington* and six other transports, surrounded by a flotilla of seven destroyers, made a successful voyage to France on June 30, 1918. According to one report Gant was only sixteen when he became a navy seaman, which reflected both his patriotism and toughness. Many years later Gant requested a copy of his discharge, dated June 17, 1960, seeking to bolster a request for parole.

Hunt registered for the draft in Sumter County but listed his place of residence and where he worked, at the time, as Jacksonville, Florida. Hunt was employed as a mechanic at Bacon and Reyson on West Monroe Street and listed his nearest relative as Mrs. I.C. Tompkins. The draft registration, dated September 10, 1918, offered his birth date as November 23, 1897, and listed him as twenty years of age. His physical characteristics included

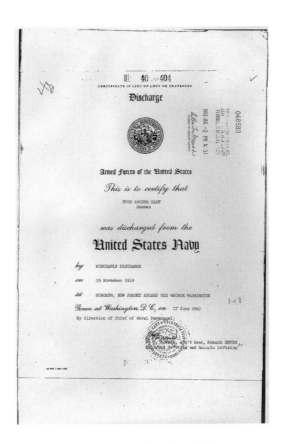

Gant requested a copy of his honorable discharge hoping to bolster a parole request.

medium height and build, with blue eyes and brown hair. There was no mention of negative commentary about his physical appearance as was later provided by the FBI.

John Riley Gant, Hugh's older brother, enlisted on April 14, 1917. Riley worked as an army wagoner in the infantry and received an honorable discharge on June 21, 1919, after serving in France. Enos L. Hunt was drafted on June 26, 1918, and began basic training less than one month later. He served as a private in Company B working as an auto mechanic and saw action in France. His place of residence at the time of enlistment was erroneously documented as Bellmore or Belwood. Perhaps nearby Belleview in Marion County was the correct town.

Though the Hunt family was better off financially than many, the presence of a stepmother, described by one living relative as a difficult woman to deal with, may have played a role in Alva's descent into crime. The Hunt boys' mother died about 1914, a critical time for the seventeen-year-old Alva. Gant's mother, Patience, apparently died around 1900, quite possibly during the delivery of Hugh Gant. As both boys grew up without

Alva Hunt, like most at the time, registered for the draft. His patriotism reflected the values of Sumter County and central Florida.

a mother during a period of hard times and poor economic conditions, perhaps the loss added to the eventual likelihood of them entering into crime. Alva Hunt's marriage to Katherine Gant, one of Hugh's four sisters, brought the trio of Riley, Hugh and Alva closer together. Gant's sisters all eventually migrated to Texas and were at some point aware of his criminal activities and even probably received some proceeds from his bank scores.

Although the Federal Bureau of Investigation pinpoints Hunt's birthplace as Bushnell, Florida, in Sumter County on November 23, 1897 or 1898, there are conflicting reports on his place of birth. His death record indicates that he was actually born in nearby Citrus County and yet other evidence suggests that Hunt was born in Clay County, a considerable distance from Sumter. Wherever he was born, it was not long before his family moved to Bushnell. Alva's father, H.D. Hunt was a native of New Jersey but became a citizen of Sumter County sometime shortly after Alva's birth. It is important to note that the FBI records from the entity's formative period are riddled with mistakes of omission and in some cases may deliberately include misleading and prejudicial *facts*.

Riley Gant received an honorable discharge for his efforts during World War I in France. He served as the initial gang leader until a fatal shootout at Penny Farms, Florida.

According to Mr. Ronald Hunt, a family descendant, Alva's mother was from Green Cove Springs, a short distance east of Penny Farms in Clay County. Penny Farms was later the site of the robbery gone wrong that resulted in the death of a gang member. Alva's father, H.D. Hunt, died January 28, 1938, a significant year in the criminal life of his son. His obituary ran on the front page of the *Sumter County Times* and described him as one of Sumter County's "most wide-awake, progressive citizens, who served three terms on the Board of County Commissioners, several years as a councilman for Bushnell, was elected mayor recently, chairman of the county democratic committee, member of the Masonic Order, Order of the Eastern Star, Odd Fellows, and deacon of the Baptist Church." In addition, Hunt owned the first Ford dealership in the area and served as a manager at a local lumber and hardware store, as chairman for a pro-America rally and as president of the Sumter County Chamber of Commerce and the Picnic Association.

Surviving him was his wife Mabel, who was stepmother to Alva; Mrs. Eva Thompkins and Miss Myrtis Hunt, both of Bushnell; Mrs. John Thompkins

H.D. Hunt served in many capacities as a leader in Sumter County, including managing a building supply store. (*Sumter County Times*, date unknown)

of Lakeland; Mrs. John Reeser of Bradenton; Mrs. Kester Stewart of Ocala; stepdaughter Mrs. Charles Cox of Fort Myers; and four sons. Enos and Harold avoided lives of crime. Truby and Alva did not. Of the latter pair, only Alva actively pursued a life in crime while Truby dabbled in what might be termed "youthful indiscretions."

The Hunt and Gant brothers, due to their rural upbringing and the times, were all tough. Enos worked assembling Fords that were offloaded from the train that passed through Bushnell. Truby and Harold were rumored to have been involved in bootlegging, and Truby might have carried a scar on his rump from a gunshot during a bootlegging excursion. Harold, said to be slight of build, fought bare-knuckle bouts for money and often got the boys into chaotic circumstances. Their only way out was through fighting. The rugged lifestyle and hard times produced equally rugged and hard individuals.

Leland Hawes's 2001 article in the *Tampa Tribune* took a look back at the Hunt-Gant combine and highlighted Gant's hard and rustic life. According to Hawes the *Tampa Daily Times* of the period quoted an experienced law enforcement officer who said that Gant was "a woodsman [who] knows every cattle trail and side road in South and Central Florida." The officer added that Gant could "hide in flat woods for weeks without being seen by any but his friends."

Economy, Banking and the Rise of Gangsterdom

Florida's poor economic conditions preceded similar national ones by a handful of years. Historian Cantor Brown Jr. suggests that this condition may have actually "eased" the state into the nationwide Depression rather than the abrupt way others were absorbed. That is not to suggest that the situation was promising, though at the time financial experts hopefully believed it to be. A financier stated in 1931: "Florida is in a better economic condition than most other states in the union" and added that its business future was bright. Perhaps he was too close to the situation or, more likely, he was trying to instill President Hoover's confidence in laissez-faire capitalism.

Florida was said to have simply continued along in a stagnant economy before it began a downward trend starting in 1926 when the Florida Land Boom went bust. The 1929 market crash did not affect Florida as severely as it did many other states since the land bust had already had a deflationary impact over the three years preceding. A poor economy, a letdown in national discipline and national prohibition resulted in conditions that were ripe for a crime spree. Most of the spree centered in the Midwest though gangs were not localized and operated across state lines with impunity and regularity. The year 1924 saw a bank failure in Sumter County noted in the *Sumter County Times* as an example of what was to come by the middle of 1926. Yet articles about tourist camps "throughout the county" and a hopeful one about potential oil drilling depicted a skyrocketing local economy and a limitless future.

Florida's Ashley Gang had been caught that November, and area criminals William "Wild Bill" Henderson, Thomas Castello and Franklin Levines robbed the Coleman Bank. The three were apprehended and, in

1927, executed through electrocution for bank robberies and at least one murder. Additional area bank robberies were noted in the *Sumter County Times* during 1926, while other articles promoted Sumter County as an area where land investment could prove profitable.

Properties were changing hands, including the $75,000 sale of a hotel north of Bushnell, and subdivisions were platted and advertised at a relentless pace. Contractors and developers bought chunks of advertising offering their building services and new subdivisions. Road building was a developing issue and H.D. Hunt wrote a progressive and positive article promoting the construction of roads in Sumter.

A March 12 article discussed "two young men" who robbed a Mr. Holt near Center Hill and Bushnell. The Essex sedan the robbers used bore Georgia plates and also bore the unconscious Mr. Holt, who was dropped in woods located south of Webster. There is no evidence to suggest that Hunt or Gant were the young men responsible for the crime, but the incident depicted the violent conditions that became commonplace.

As 1926 reached its halfway point the erratic nature of lending and speculating began to noticeably impact area banking. On June 4, 1926, Citizens Bank closed its doors, and in early July the Bank of Groveland in nearby Lake County followed suit. The Bank of Wildwood, according to a July 11 story, was still growing.

The burst of the land boom bubble hit Florida hard. Between 1926, the year of the burst, and 1930, the assessed value of Florida real estate dropped from $628 million to $441 million. The lenders who helped spur the real estate feeding frenzy reaped their benefits in 1925; 62 national and 274 state banks reported resources of $943 million. Merlin Cox and Charles Hildreth cover much of Florida's economic turmoil in their *History of Gainesville, Florida, 1854–1979.* A year later those resources fell by approximately one-third and 40 banks closed their doors.

The Florida economy vacillated slightly in 1927 with a brief influx of new businesses in Bushnell. Among the five new establishments were a five-and-dime store, a packinghouse, a bottling works and a new garage. Ever-present crime reared itself that year with the robbery of the post office at St. Catherine in late August. Facilitating early Florida tourism and real estate speculation was the growing, widespread usage of the automobile and the growing construction of a statewide system of public roads. By 1928, over 1,588 Florida roads were paved with nearly 60 more under construction.

In 1929, the year of the stock market crash, 57 national banks failed and 178 state banks reported further losses of resources. In Florida alone, 43 state banks and 10 national banks failed. In 1930, 34 banks closed, while the following year a slight rebound of confidence resulted in only 14

failures. The upward trend continued in 1932, with only 12 banks closing, but in 1933, a downward spike associated with the growing Depression caused 25 banks to close. Additionally, the Florida hurricanes of 1926 and 1928 negatively impacted the state's economy. A blight brought on by the Mediterranean fruit fly added to nature's menace on Floridians' economic survival. In Orlando, for example, citrus production fell from twenty-eight million boxes for the 1928–29 harvest to only seventeen million the following harvest.

Florida's population grew gradually from 1925 to 1930, despite the real estate speculators churning property, and relief rolls gradually fell from sixteen thousand in 1932 to about four thousand in 1935. In a sense Florida was prepared for the nationwide and international Depression by its three-year head start. By late 1930 some spoke with confidence about the state. An economist found "no evidence" that Floridians were financially broke in 1932. He added that building construction was at a greater pace than the previous year, unemployment was low and the "usual horde" of Floridians was able to finance summer vacations. Shockingly he added that the people were "living well, even buying luxuries" to some extent. Much evidence exists on the disastrous impact of the Great Depression on Florida, which makes economist's statements seem myopic or hopeful. Luxury items and summer vacations were not an option for the majority of residents of Sumter County.

Prohibition, too, bares some of the blame. Bootlegging created an underworld that grew into a profitable racket. J. Edgar Hoover confidant and Bureau number-two man Courtney Ryley Cooper considered bootlegging a gateway, entry-level crime with participants often growing into crimes like robbing banks. He documents in *Ten Thousand Public Enemies* that "new types of men have taken up crime—men who began by dealing bottles off the hip and who have graduated to robbing banks." Among the bootleggers and others who graduated to more violent and lucrative crimes were lists of what were considered traditional "American" names. In *Persons in Hiding*, J. Edgar Hoover tabulated a list of Anglo-sounding names that, to him, presented a quandary. It was not just those with immigrant names like Capone who were committing crimes to a shockingly greater degree.

Some of the names are familiar to fans of the gangster era, like Keating, Nash, Floyd, Gilmore, Underhill, Brady, Kelly and Miller. Others are less well known, though to Hoover they were important at the time and represented true Anglo-Americans, names like Holden, Gunn, Kent, Simons, Doll, Holland, Heady, Short, Cooper, Melton, Reece, Austin, Maroon, Venable, Carroll, Phillips, Sadler and Smith. Curiously, considering their alleged notoriety and their obvious Anglo-American-sounding names, Hoover did not mention Gant or Hunt.

According to Hoover, a large number of those who vied for public enemy status were reared in "the best of all-that of the little community, and even of the farm." Many theories exist to explain the rise of gangsterism in the 1920s. In general a "national letdown" after World War I combined with the implementation of national prohibition created fertile ground for its rise.

In March of 1933 President Roosevelt called for a bank holiday; Congress passed the Emergency Banking Act and officially launched the Civilian Conservation Corp. Those many Floridians not gathering luxuries or taking summer vacations felt the positive impact of Roosevelt's First New Deal. Two months later the Federal Emergency Relief Act, Agriculture Adjustment Act and Emergency Farm Mortgage Act were enacted. More alphabet programs flowed from the White House and Congress to bolster the nation's economy. While Roosevelt's first one hundred days were intense and productive, the immediate results of the legislation did not coincide with the rosy picture presented by observers too close to the scene.

The Volstead Act, which made the manufacture, sale and usage of alcohol illegal, had its grip on the nation. However, despite having no legal ability to acquire alcohol, area residents managed to indulge in drinking. According to Cantor Brown Jr., nearby in Polk County during 1934, citizens watched as "illegal boozed flowed." Lakeland's J.L. Bloodworth reported to Governor Fred P. Cone later in 1937 that conditions were deteriorating. He wrote, "We have running wide open bar rooms on every block, well established and protected gambling houses and these things will lead to murder and even worse." Lakeland resident and 1936 gubernatorial candidate E.E. Callaway summarized conditions succinctly by saying that Polk County was "the worse 'Hell Hole in America today.'" Sumter's southern border meets Polk's northern border and its conditions may have spread across county lines.

While Mother Nature impacted Florida's economy, most of the weight fell on the Volstead Act and the weakened economy. The combination of man-made circumstances and natural forces led to the rise of gangsterism and helped create a recipe of depravity, disregard for the law and an environment ripe for the picking. Hoover suggested another novel interpretation stating, "I am afraid that I should be forced to lay the blame squarely at the door of parental overindulgence."

With farm foreclosures on the rise and, by 1932, nearly one-quarter of all able Americans unemployed, many rural people moved to cities. Coinciding with the high migration numbers, newspapers discovered that people got vicarious enjoyment from the misadventures of gun-toting bank robbers. Capitalizing on the mass interest, the papers used "blazing headlines" and christened gangs and gangsters with names like Machine Gun, Pretty Boy and Baby Face. At the same time honest citizens were able to root for the

lesser bad guy, the bank robber, over the worse bad guy, the bank owner. After all, the bank owners were the ones foreclosing on family farms while the bank robbers were stealing the bank's money.

The incidence of bank robberies and the dedication that the public showed toward following their antics became daily newsprint fodder. The Texas Sherman Daily Democrat "routinely ran a front page box" with the headline "Today's Bank Robberies." Details were brief and included the locations, number of robbers and the amount of the take. The pantheon of gangsters and hooligans included the familiar—John Dillinger, Bonnie and Clyde Barrow and Ma Barker and her sons—and the less well known, like Alvin Karpis and the Purple Gang. For a time these were heroes for whom the average citizens could root. "A wave of idolatry swept the depression wracked nation," according to author L.L. Edge, and the period produced many bank robbers. Bank robbing became the activity of common men who robbed institutions owned and run by the well-to-do. Bleak conditions served to force many rural farm boys to the cities to find work. Some found illegal activities instead of a steady, legitimate job since unemployment levels had skyrocketed to nearly one-quarter of the nation's working pool by 1932.

Others attributed the outbreak of crime and, especially, bank robbing to changes in technology and society. "Public apathy, the automobile, the Tommy-gun, the mafia, and the mushroom growth of cities contributed to this crime explosion." Coincidentally, "fast getaway cars had hit the mass market before police radios." Whatever the impact, the names of those who took advantage of the burgeoning technologies are numerous. Harvey Bailey, considered a master bank robber, was involved in twenty-nine bank jobs. He, unlike so many, lived a long life, eventually dying in Joplin, Missouri, in 1979 after serving a sentence of twelve years at Alcatraz before he was paroled in 1965. Bailey interacted with robbers from different outfits.

Alvin Karpis entered Alcatraz on August 7, 1936, and left prison in 1962. Like Bailey, Karpis outlived most of his peers, dying in Spain in 1979. Karpis at times worked independently but teamed up with other combines, including the Barkers on some occasions. Ma Barker, the reputed brains behind the brawn of the gang, was more likely a dependent dullard who relied on the gang's proceeds for her survival. Bailey was familiar with Ma and the Barker-Karpis team and said that "the old woman couldn't plan a breakfast" let alone a bank heist or kidnapping. The Barker-Karpis combine, like most others throughout the nation, had a "floating membership" as members were killed or arrested. Some who survived and remained free moved on to form their own crews or branch out into different pursuits.

Barely known Eddie Green provides an example of those with the ability to move and meander with flexibility from gang to gang. He was a Dillinger gang member but also dabbled in jobs with the Barker-Karpis combine. At the time of Green's death, partners he had worked with were in disparate locations. Some were in Glasgow, Montana, while others were in Las Vegas, Nevada, and Allandale, Florida. The Hunt and Gant concern utilized different participants with different skills like many other criminal outfits. Harvey Bailey brought Machine Gun Kelly in on a bank job. The plan was for Bailey and his crew to rob a bank in Sherman, Texas. The main gang would meet Kelly near the Louisiana state line with a second getaway car. Later they planed to reassemble in Hot Springs, Arkansas, which was a "protected city." A protected city, or "good town" in criminal parlance, was one where gangsters, gamblers, kidnappers and hooligans of all types gathered for the pleasures of utilizing prostitutes and drinking in a secure environment. Security was often provided by town officials and officers who the gangsters bribed. In addition to Hot Springs, St. Paul, Minnesota, and Joplin, Missouri, numerous lesser-known towns acted as "cooling-off joints" or protected cities.

There is strong evidence to suggest that Hunt and Gant, who operated across the south, visited Hot Springs at least once. There they may have interacted with well-known criminals like Bailey, Kelly and Alvin Karpis, who was there in March of 1936. It is possible that the Hunt-Gant combine crossed paths with Karpis more than once. Karpis and Harry Campbell meandered from Hot Springs and wandered through Texas, Mississippi and Florida, contouring the Gulf Coast from 1935 through 1936.

The mass interest and even reverence for the glitz and glamour of gangster life died with a growing number of publicized kidnappings and the Union Station Massacre. On the morning of June 17, 1933, four law enforcement officers and their prisoner, Frank "Jelly" Nash, were ambushed. "Pretty Boy" Floyd, Adam Richetti and Verne Miller were accused of committing the crime in an attempt to free Nash. The brutality and public setting of the massacre shocked the citizenry and led in part to less reverence for gangsterdom. The Urschel and Bremer kidnappings then turned the gangster into a proper villain.

In 1934 Henry Suydam was appointed as a special assistant in the Bureau. He was charged with doing public relations work to change the federal agent's image to that of the hero thereby making the gangster the bad guy. One major way that the FBI promoted its cause was its role in movies. In 1935 alone there were sixty-five movies where the "G-man" was a positive and likable character. People were fed up with crime and sent letters to newspaper editors calling for measures as extreme as "public hangings and floggings" and even martial law. The view then, as now, was that penal

institutions were "concealing golf courses and other delights concocted by moonstruck penologists" for the prisoners. Everyone had an opinion. Dentists blamed bad teeth; endocrinologists thought it was the result of an internal deficiency; drinkers blamed those in favor of prohibition; and those opposed to drinking blamed alcohol and its required enforcement. Clergymen even made pleas for a return to Sunday blue laws.

Some saw little change in the character of criminals during the Depression from those of the Old West. In place of horses they used cars, and Thompson submachine guns supplanted the Colt .44. Many thought that the brief rise in crime during the Depression centered on the middle states. The Midwest "crime corridor" was the name given the area where outlaws had reigned and ruled since the border wars and the Civil War. Yet gangsterdom was not just a Midwestern phenomenon, just as sure as depressed conditions were not.

According to the *American Bankers Association Bulletin*, issued by its insurance and protective department, there were 631 bank burglaries and holdups reported in 1932. That was the peak year for such bank crimes. They reported for the year ending August 1, 1935, 326 robberies, as opposed to 422 the previous year, demonstrating a decline. James E. Baum, manager of the protective department of the ABA, explained the decline's main contributing factor as "the large number of professional bank robbers taken out of circulation through death or imprisonment." During the period of 1934–35, 20 bank robbers were killed. Victims who were shot and survived or otherwise physically injured during robberies included 17 bank employees, 15 bystanders, 12 arresting officers and 15 bandits, totaling 91 casualties as opposed to 221 total for the year previous.

Between 1914 and 1934 2,500 banks were robbed in the United States. Twenty-two known gangs, who were involved at least occasionally in robberies of national banks, were identified by authorities. The number of unknown combines focused on smaller, "unprotected state banks" was not known. In the early 1930s three-quarters of banks robbed were located in the Midwest. The year 1932 saw 77 bank burglaries and 554 bank holdups. Burglaries occurred during off-hours while holdups were perpetrated during operating hours. A precipitous decline from 1932 to 1943 corresponded with the easing of the Depression and American involvement in World War II. Bank crimes declined from 631 to 26 during the same period.

By the mid-thirties the Depression was showing some signs of recovery. Many of the failed banks sought to reopen their doors. From 1932 to 1934 banks were robbed at a rate of two per day. By 1936 the rate was less than one per week. Of those hit, the majority, approximately 80 percent, were in smaller communities with populations totaling fewer than ten thousand.

Contemporary author Herbert Corey, living through the ravages of life in the Depression amid the gangsters, wrote of the lack of "romance in crime." According to him their standard of living was equal to "those of pigs in a wallow." They were "ignorant and sullen louts" who lived in fear of friends and partners as much as the officers who pursued them. The life of a gangster, according to Corey, was one of fear and paranoia. When gangsters were flush with cash they relaxed in drunken debauchery and familiarized themselves with women of lesser character.

The Art of Stealing Cars and the Science of Robbing Banks

S tealing cars in the 1920s and 1930s was fairly easy and routine. An auto thief "merely clipped the cable, attached an electric wire with a radio clip at one end" and fled away from the scene of the crime. The trick was not the theft but the ability to turn the vehicle around, or convert and sell it. It was also potentially profitable if the job was well organized because each state had its own license tags and independent automobile laws. Therefore, cooperation from state to state between law enforcement agencies was impracticable. It was the National Motor Vehicle Theft Act that eventually brought the much-needed coverage that the federal umbrella provided.

Auto theft organizations typically included different participants. The thief was generally one cog in the system and needed an established relationship with a fence. The fence, in turn, needed connections above him. According to Melvin Purvis, the thief earned, "at most, thirty-five dollars for every car" he appropriated and delivered. Hunt and Gant may have devised a system that consolidated the profession by eliminating specialization between auto thief and fence.

Automobile manufacturers attempted to stay ahead of the auto theft rings. Complex number systems were given to engine parts to identify parts taken from a vehicle and put into a different one. The manufacturers were the only ones who possessed the key to solve the number system. For example, a vehicle with "motor number Y-166,667" was manufactured with a generator numbered "Y-42,525." Later that vehicle revealed, upon inspection, that the generator accompanying the vehicle had a completely unrelated number—M-42,525.

Auto thieves were not too far behind. They developed a system called "mother-car proposition." The system involved the legitimate purchase of a

vehicle by a fence. The car thieves then stole several of the same model and turned the vehicle over to an engine man. He, in turn, filled the numbers up on the stolen cars and stamped the same numbers taken from the legitimate vehicle. Upon inspection a vehicle with a matching number could pass as legitimate even if it had been stolen.

An article appeared in the *Tampa Morning Tribune* on Tuesday, November 8, 1927, with the title "Officer Shows Great Decrease in Auto Thefts." The story lent credence to the idea that an organized auto theft ring had been operating in Florida. The article subtitle showed a decrease of stolen vehicles in the Tampa area from 1,150 to 900 over a one-year period. Automobile thefts decreased by 25 percent in Florida from October 1, 1926, through October 1, 1927, compared to the same period from 1925 to 1926. During 1926, approximately 4,000 vehicles were stolen or reported stolen and 3,330 were recovered. Also in 1926, Hillsborough County led all Florida counties in both thefts and recoveries with 1,150 and 800 respectively. The numbers did decrease statewide. One year later thefts in Hillsborough had decreased to 900 and nearly all, 750, were recovered.

In 1926, 300 persons were arrested in Florida for automobile theft with 250 convictions. A year later 400 persons were arrested with 350 convictions statewide. In Hillsborough County there were 100 arrests and 75 convictions for auto theft in 1926 while in 1927 arrests were up to 160 with 100 convictions.

Five days after the story, the *Tampa Sunday Tribune* published an article titled, "77 Cars Stolen in State in October." Of the seventy-seven stolen, thirty-one were recovered. A trend seemed to emerge. The thieves appeared to have a "particular weakness for the touring car" since twenty-four of the vehicles stolen that month were of such design. Next in line were the roadster and the sedan, tied at seventeen each. Fourteen coupes, two trucks and a tractor were taken as well. Jacksonville appeared to be the area of heaviest action during October with thirty-three heists; Miami suffered seventeen, and Tampa six.

Automobile thievery proved to be one of the best and most lucrative criminal fields. "The main body of depredation is the result of a well-organized auto theft ring." Within the ring the "numbers changer" was a highly skilled and prized worker. Because of his ability to alter motor serial numbers, the changer garnered a high percentage of the take. Some were so proficient that the numbers were often invisible to "microscopic inspection." Often machine shops took in "hot" cars from thieves, stripped them, reconditioned the parts and then sold them through discount wholesale stores.

Always attempting to stay one step ahead of the criminals, law enforcement found ways to "bring back the original numerals." After the spot where

OFFICER SHOWS GREAT DECREASE IN AUTO THEFTS

Stolen Cars Here Fall Off From 1150 to 900 in Year

Proof that automobile theft was a widely practiced crime. (*Tampa Morning Tribune*, November 8, 1927)

engine numerals were originally embedded was etched to a smooth finish, acid was applied. More often than not, a faint outline of the original numerals appeared. In cases when they were illegible, the application of heat helped.

As sure as automobile thieves became proficient, bank robbers quickly became learned at their craft. Proficient bank robbers were able to get in and out of the target bank in between two and five minutes. A great deal of planning went into what would become a successful bank heist.

Robbers learned how to "case" a bank and found that minute details were critical. Those who ignored casing and detail were usually killed, winged by a gunshot from law enforcement or incarcerated early on in their career. Lesser amateur criminals learned from the professionals.

Hugh Gant and Alva Hunt excelled in fencing auto parts and stealing cars before being incarcerated. After their time in jail they entered the bank robbing profession. Hunt more than Gant would have interacted with pros while in the Atlanta penitentiary, and it was commonly said that "prohibition made the gangsters, but prison made the gangs." Bank robbing became something of a gruesome and sometimes violent science. One practice that grew common was to put victims in the vault after it was looted. The hope was that they would remain in there long enough to help the crooks escape. Other outfits preferred to take a victim along for the ride. Generally one or two kidnap victims were forced out of the bank to help load loot into the waiting getaway car. Some bank robbery combines chose to force those they kidnapped to "ride the running boards." Typically they were jettisoned from the vehicle once it was clear that the gangsters were approaching the city limits. Considerate robbers slowed the vehicle down.

It was important and helpful to have an understanding of bank and law enforcement procedure in the targeted town. Local residents sometimes provided critical information for a small cut of the take. Courtney Ryley Cooper interviewed Eddie Bentz for his book *Here's to Crime*. Bentz, a supreme bank robber who was credited with involvement in over one hundred bank heists, suggested that a crew needed a place in the vicinity from which to work that was out of reach of the police. According to Bentz, "All the other big yeggs used" a headquarters. "Yegg" was a term used to denote a bank robber or safecracker during the period. He likened casing, or fingering a bank, to playing solitaire: "You drive past the bank a few times and size up the surroundings" to identify potential getaway streets, police stations and officers' posts, and whether the "bank's got a squawker on the outside" to alert the town. A "squawker" was an outdoor alarm.

Proper behavior was important. Flashing money, engaging in fights and carousing in the area brought negative attention. The idea was to blend in, not stand out. Bentz went on to even suggest meeting with the bank manager to discuss potentially opening an account. A slick bank caser might have even gotten an inside bank tour under the guise of reassuring himself of its safety. No detail was left out.

Study was given to ascertaining the character of the tellers. For example an older married man, knowing the bank was insured, was probably less likely to fight against the robbers, making it a safer bet for the crook. When the caser was satisfied with the bank's interior and the immediate adjacent

area outside, he sought to survey the getaway route. Running the roads was "the real fun of bank-robbing," according to Bentz. He suggested starting from the headquarters and taking a "circuitous route out of town" checking out the back roads. Repetition gave the crew, and especially the getaway driver, familiarity and confidence. Ultimately, a crew would seek "the cat, the unused roads" that lead in a straight line out of town, avoiding as much as possible other towns, cities and main thoroughfares.

Another cooling off joint was recommended at least one hundred miles from the site of the robbery. In order to foil witnesses, passersby and police, it was recommended to travel in a zigzag pattern. Getaway maps, called "gits" or "run and gets," were written in code and were a good back-up device when the frenzy of a car chase or gunfight occurred.

The git might start with a zero to represent the bank as the starting point. If preplanning determined that a right turn was needed one-tenth of a mile from the bank, the robber would mark *.1-rt turn* on the git. Map detail might then show that a left turn was needed another eight-tenths of a mile away and would be indicated by *.8 lf-turn.* Landmarks helped the getaway driver know with confidence that he was on the correct track. If the driver needed to take a particular action at a white barn on the left-hand side of the road that was one and two-tenths miles from the last point, he could quickly refer to the getaway map and see *1.2-wbl.* A bad bridge would be indicated by *bb* and a road section that was bumpy and deemed bad, requiring more driving finesse, would be coded as *bbr* for bad, bumpy road.

Speeds were given for turns. Fuel drops, places where the robbers or accomplices had left cans of gasoline, were noted since service stations were often dangerous or not available. "Gits," casing banks, cat roads and more added to the romance of the Roaring Twenties and the life of a gangster. Added to that was their use of coded *secret* messages. Bentz and other crews utilized coded messages in newspapers to gather their gangs together from far-flung places before a heist, for planning and then after the job was completed to divvy up spoils, nurse wounds and enjoy the spoils.

Glamour and romance filled the lexicon of the gangster with more expressions such as "packing a gat" and "taking it on the lam," and mixed with images of beautiful molls, plenty of cash and exhilarating car chases. Successes for criminals depended on their level of artistry when stealing and fencing automobiles and their scientific knowledge when robbing banks. Hunt and Gant proved proficient in both endeavors.

The FBI and the Hunt-Gant Gang

In 1908 Attorney General Charles J. Bonaparte appointed an unnamed force of special agents to become an investigative arm called the Department of Justice. The following year they were named the Federal Bureau of Investigation. The FBI operated under its original authority as the Division of Investigation until 1935.

Initially the agents focused on bankruptcy fraud, antitrust crime and neutrality violations, sabotage, sedition and draft violations during the First World War. With the passage of the National Motor Vehicle Theft Act their jurisdiction broadened.

In 1924 the Identification Division of the FBI was created by an act of Congress. Fingerprint records from the National Bureau of Criminal Identification and from the Leavenworth Penitentiary totaled over 810,000. According to Herbert Corey, more than 4,000 bank robbers were known to the FBI by 1936. By that same year Hoover and the FBI had accrued nearly 5.3 million sets of fingerprints. The consolidation of the prints into a federal repository helped law enforcement as criminals made use of the car crossing state lines.

The gangster era, which began about 1920 and coincided with Prohibition, erupted with kidnapping and bank robbery. At that time they were not federal crimes, but finally, in 1932 kidnapping was made a federal violation with the passage of a federal kidnapping statute. The period from 1933 to 1939 required "an aggressive, hard-hitting campaign against gangsters" who were "running wild" across the United States in the aftermath of Prohibition. The period has been described in many ways. Vivid descriptions from Don Whitehead's *The FBI Story* painted the period as "slam-bang, rough and tough years of blazing gun battles" with notable gangster combines.

The FBI and the Hunt-Gant Gang

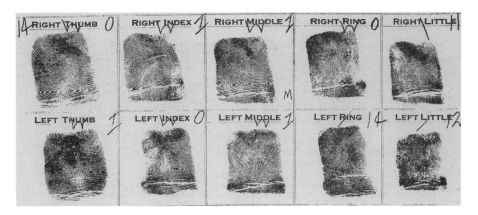

Hugh Gant's fingerprints taken from a wanted poster.

Initially the feds were powerless to take on gangsters and the "underworld empires" they illegally birthed. Before 1934 the feds were authorized to investigate bank embezzlers of Federal Reserve member banks. As long as the gangsters did not violate federal law the feds could not touch them.

To thwart their seemingly untouchable status Congress approved many new crime bills and President Roosevelt signed them into law in May and June of 1934. That was the year that special agents were authorized to carry weapons. Among the bills Roosevelt signed were the National Bank Robbery Act and those making it a federal crime to assault or kill a federal officer, to rob a federal bank or to unlawfully flee from one state to another to evade prosecution or giving testimony. Banks were being robbed at a sixteen per month clip at the time. The "figure was cut down to four" shortly after the passage of the National Bank Robbery Act into law. Anyone carrying $5,000 or more worth of property across state lines was technically guilty of a federal violation. Most importantly, the FBI was given the full power to arrest and the full legal authority to be armed while carrying out its duties. The Antitrust Act, which forbade the restraint of interstate commerce, was another vehicle the FBI employed.

Since crime was not usually a local pursuit, gangs often crossed state lines. The National Motor Vehicle Theft Act, also known as the Dyer Act, prohibited the transportation of stolen motor vehicles across state lines. Placement of FBI field offices spread the reach of the Bureau's arm. One location of key southern field offices of the new FBI included Jacksonville, Florida.

Before the Union Station debacle and John Dillinger's turn toward more violence, it was the FBI, not the criminals, who was looked at as the enemy. Dillinger's short reign as public enemy number one, with the help of his

associates, included as many as ten murders, seven woundings, a number of bank robberies, the looting of three police weapons arsenals and three jailbreaks. The Barker-Karpis combine reigned from about 1931 until 1936. They were likewise ascribed with ten kills as well as the wounding of four men and the looting of approximately $1 million in cash and securities. They were involved in at least two major kidnappings before the crew's demise.

Hoover, seeking to bulk up the Bureau and its image and lessen that of the daring Dillinger and others, used increased appropriations to acquire "hired guns," former lawmen with police experience. Among those already in the Bureau's fold were John Keith and Charles Winstead, to whom Hoover added Gus T. Jones, an ex-Texas Ranger. A master at public relations and self-promotion, Hoover was accused of being a headline hunter. Offering some validity to that supposition was Hoover's personal involvement in the arrest of Alvin Karpis. "The capture of Karpis, last of the gangster kings, in an FBI raid led by the director in person, sealed the doom of the gangster era." His arrest, according to many *was* the end of the era. However, the bias toward big-named Midwestern gangsters is evident in that statement and ignores Hunt and Gant. In reality there were plenty of Hunt-Gant Gang versions on the coasts and still in the Midwest at work.

More than the end of an era, Karpis's arrest was the end of the well-publicized criminals. The FBI still forged ahead and spent and focused their resources on the capture of bank robbing gangster combines. In fact the FBI focused a three-year pursuit on Gant and Hunt. Moreover, they referenced the great gangsters who were then arrested or dead in comparison to the pair. Gant and Hunt were the main players in a drama that started in rural Sumter County and eventually spanned at least nine states and eighteen years of crime. There are gaps in their whereabouts since the pair was on the lam from the early 1930s until their capture in 1938. Earlier periods lacking information during the 1920s presumably take into account times when they were in the money and managed to avoid arrests.

Along the way the duo was accompanied by a broad spectrum of amateur and professional criminals, as well as molls, a favorite derogatory term of the FBI in the period. A moll was a criminal's girlfriend and was meant to denote a casual, sexual relationship. Typically a gang was composed of between five to eight principals and an array of minor crooks and hangers-on.

The FBI in their modus operandi file kept detailed "signatures" of the systems, routines and preferences of bank robbery combines. For example "some of them make all the people in the bank, including the customers, lie face down on the floor; other robbers force them to face the wall, or lock them in the vaults of the bank." Gant and Hunt were gangsters in the style

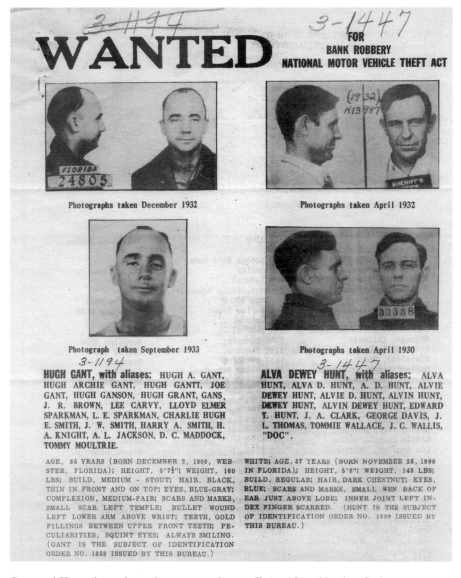

Gant and Hunt pictured together on one of many Federal Identification Orders, commonly called wanted posters.

of Pretty Boy Floyd, John Dillinger, the Barkers and Alvin Karpis. In fact, Gant and Hunt caught the personal attention of the FBI and its leader, J. Edgar Hoover, when they were called, "one of the most notorious bands of criminals ever to operate in the southern part of the United States." In addition the feds referred to the pair as "notorious gangsters" and Hoover personally and characteristically exaggerated that they were, "one-hundred

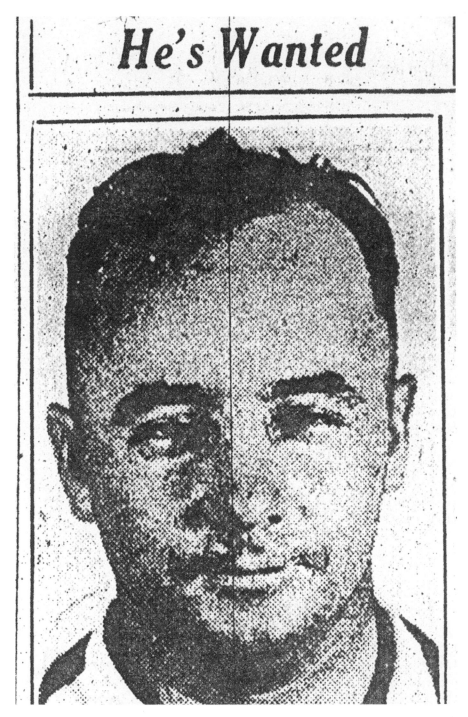

Gant's notoriety grew upon the switch from automobile theft to bank robbery, and consequently, so did the number of circulated photos. (*Tampa Sunday Tribune*, March 8, 1936)

percent more dangerous" than the likes of Dillinger or Karpis. However, there is no evidence to suggest that, like Dillinger and Karpis, they ever killed anyone.

Closer to home the Orlando Police Department called them a "statewide ring of notorious automobile thieves." Across the South newspapers pinned the terms, "desperadoes, public enemies, and bank bandits" on them. The *Tallahassee Daily Democrat* noted that they were the "nation's most sought after fugitives" at one point. Additional titles, fairly earned, included "Public Rats" and "Public Enemies #1 and #2." Rewards were offered including individual ones of $1,000 and according to at least one such reward, they were to be taken "dead or alive."

The Division of Investigation within the FBI had accumulated files of "practically every known crook in America" based on their nickname. Nicknames did not change while aliases did. Some professional crooks utilized as many as one hundred aliases. Neither Hunt nor Gant had a well-known nickname. During their crime spree, however, they made use of numerous aliases, which were gleaned from FBI reports, rewards posted in newspapers and police dockets in Tampa, Tallahassee and Orlando. Among the monikers are several surnames still common throughout central Florida.

Hugh Archer Gant's aliases included:

Hugh A. Gant	J.W. Smith
Hugh Archie Gant	Harry A. Smith
Archie Gant	Harry W. Smith
Hugh Gantt	D.D. Maddock
Joe Gant	D. C. Maddock
Hugh Gannon	Tommy Moultrie
Hugh Grant	George C. Simmons
_____ Gans	George T. Simmons
Hugh Ganson	Jimmie Wallace
J.R. Brown	J.C. Hayes
Lee Carvy	L.H. Crawford
Lee Gravy	Billy _____
Lloyd Elmer Sparkman	_____ Deyson
L.E. Sparkman	Bill Dean
Lloyd Flacer	Lamar Harry Spencer
L.E. Smith	W. Cook
H.A. Knight	W.L. Avant
A.L. Jackson	Nelson S. McCall
Charlie Hugh Smith	_____ Cannon
Charlie Hugh E. Smith	

Alva Dewey Hunt's aliases included:

Alva Hunt	Tommie Wallace
A.D. Hunt	J.G. Wallis
Alva D. Hunt	Tommy Lane
Alvie Dewey Hunt	Gordon L. Fletcher
Alvie D. Hunt	G.L. Fletcher
Alvin Hunt	D.M. Morgan
Dewey Hunt	D.N. Morgan
Alvin Dewey Hunt	D.P. Morgan
Edward T. Hunt	J.R. Adams
J.A. Clark	_____ Watson
J.A. Clarke	Doc _____
George Davis	_____ Griffin
J.L. Thomas	W.W. Warren

Accomplices, family members involved in crime and love interests employed aliases as well. In the case of Truby Hunt, his name was mistaken in the press and law enforcement circles and James Backus's name was alternately spelled Bacchus.

Name	Relationship	Alias
John Riley Gant	brother	John Edwards
Truby Hunt	brother	Truly Hunt
		Trubee Hunt
Weyman Verble	accomplice	Raymond Verbel
Thelma Gant	wife	Thelma Jackson/Fields?
Inell Jackson	accomplice	Odell Jackson
Lloyd Miller	accomplice	David Carson
Pete Collins	accomplice	L.M. Collins
Benjamin Alvarez	accomplice	Albert Lopez
		Frank Lopes
		Frank Fernandes
		Louis Diez
Jack Ray Oliver	accomplice	J.D. Scrivner
		Herbert T. Weir
		Jack Scrivner
Leroy Chastain	accomplice	Carter Lee

Other members of their crime consortium who employed no known aliases during their association with Hunt and Gant are Alene Bledsoe (a Hunt paramour), Audria Lee Cotton (a Gant paramour), Ada Weir, Elbert Croft, _____ Wilkinson, William F. Kelly, Thomas Bradley Shaw, James Backus, Johnny Burke and Bill Bonner. James Backus and Johnny Burke may have been the same person with one of the names, most likely Burke, being an alias.

The constant members of the gang, Alva Hunt and Hugh Gant, employed at least sixty-six aliases and partnered with as many as eighteen accomplices, and probably many more, throughout their eighteen-year career. Hunt used, in addition to eight variations on his given name, nineteen names taken from local Sumter County family surnames and his imagination. Gant similarly utilized familiar names of Sumter County residents. Among them were Sparkman, Knight, Moultrie and Simmons. Of his thirty-one aliases four were variations of Hugh Gant. John Riley Gant, initially the gang's leader, posed as John Edwards and Riley Gant. Truby Hunt apparently never employed an alias though newspaper accounts and prison records list him as Truly and Trube and the 1920 Florida Census offered Trubee and Trupie.

The Early Crime Spree

The FBI's March 30, 1938 summary, written in the flowery, broad-brush prose of the day, reported that "one of the most notorious bands of criminals ever to operate in the southern part of the United States had its origin in the wide expanse of that impenetrable jungle known as the Everglades of Florida." But to be more precise, it actually began in Sumter County, located in central Florida within a triangle formed by Tampa, Orlando and Ocala and a considerable jaunt north from the Everglades.

The war on crime sought to change the public persona of gangsters from heroes to villains. Their efforts to do so included publicity that painted a picture that *may* be true. Today we call it spin. The FBI described Hugh Gant in terms that today would be considered politically incorrect at best and pejorative at worst. They described him as, "mean, vulgar speaking, squint-eyed, and the 'rough and tumble' muscular type." Today we find comparisons like, "he is always grinning like an evil demon," almost quaint for its lack of tact. After describing him as rough and tumble they added that he is "chunky and bald, has a sallow complexion and possesses a noticeable southern drawl." Hunt received equal treatment as he was described as a "slender, dark-hued individual with piercing eyes, and his face is splotched and pitted." Agents ascertained that Hugh Gant was "equally at home in the swamp country, rural or urban sections" and "could live in the woods indefinitely." They noted that he possessed "numerous spots in Florida and other Gulf Coast States where he could hide out safely." Gant allegedly "found his hideouts in the larger cities and usually kept away from his criminal associates until they were ready to 'pull a job.'" Hunt was considered serious by federal agents as opposed to Gant. Interestingly federal agents appeared to not know when Hunt and Gant first became acquainted.

The Early Crime Spree

Alva Hunt's birth date of November 23, 1897, or 1898, made him the de facto leader upon Riley Gant's demise because of his elder status and prowess with automobile mechanics. Not surprisingly the FBI called Hunt a "proficient mechanic" and regarded him to be "an expert in stealing and disguising automobiles." They even noted that his ability to alter serial and motor numbers and personally change the color scheme of the cars by repainting them led to "considerable difficulty" in identifying the vehicles. Hunt was referred to as the elder of the two and also "much bolder." The summary states that he easily made friends and that while Gant earned loyalty through fear and intimidation, Hunt was truly liked. The favorable description continues: "Hunt is reputed to be good-natured, well-mannered, dresses nicely and has an outward air of respectability and seriousness." Then, in typically demeaning fashion, it was added that he had an "uncontrollable desire for women, and has had numerous paramours" during the latter years of his travels.

The first documented indication that Hunt and Gant might be on the road to becoming the most wanted desperadoes in the south was the innocuous arrest of Hugh Gant in Orlando, Florida, for public intoxication. It was 1920 and he was fined a sum of twenty-five dollars. A gap of nearly four years in recorded legal problems followed the intoxication charge, so it is possible that neither man was arrested or even involved in any nefarious activities during this period. But by 1924 Hunt and Gant had teamed up fencing stolen automobile parts, and Sumter County case 172 versus Hugh Grant and case 183 against Alva D. Hunt involved the receipt of two Dominant Cord automobile tires with inner tubes. The property belonged to S.L. Hiers and the case resulted in an acquittal. Two themes emerged with this crime—the misspelling of Gant's surname, which occurred often, and the focus on automobiles, which would remain consistent during both phases of their careers.

At some point Hunt left Sumter County and headed back to the familiar Jacksonville area. While there Hunt ran into problems with the law. The arrest of Alva Hunt by the Jacksonville Police Department while he was employing the alias J.A. Clark on February 19, 1924, earned him case number 3474. The four-year gap in activity and Hunt's arrest in Jacksonville suggest that Hunt was more heavily involved in crime and lend sketchy evidence that while Gant was a wild youth, it was in fact Hunt who was the driving force behind their early criminal activities. This time, instead of fencing the property, Hunt had attempted to steal the vehicle and was charged with automobile larceny by the U.S. commissioner for the Federal Grand Jury. He was released on bond, but the bond was later estreated. Hunt was not reapprehended until two years later after reneging on the bond. He and Gant made habit of foregoing bonds in lieu of freedom.

During another brief period with no recorded legal problems, the pair was presumably involved in further criminal pursuits and, to their credit, probably legitimate ones as well. The next occurrence was the apprehension of Hunt, employing the alias Dewey Knight, by the sheriff's office in Fort Myers on July 10, 1926. He was released, and in 1928 the indictment was dismissed. A steadier stream of arrests followed the third such for Hunt.

The Tampa Police Department brought Dewey Hunt in on November 4, 1927, for suspicion of automobile thievery. One week later Gant was arrested in conjunction with the same theft. Case numbers 1353 and 1350, respectively, cemented their upgrade from car parts fencers to thieves. These cases were placed on the absentee docket on June 20, 1928, and never tried, possibly because two others arrested with Hunt and Gant that day were acquitted in February.

By 1928, Hunt and Gant were known car thieves and were familiar to police departments. Hunt was neither done with automobile larceny, nor with traveling lengths for the attempts. In 1926, Hunt had headed south for Fort Myers, Florida, and was apprehended for automobile theft. Operating as Dewey Knight, he was released. A lack of technology and coordinated, intrastate communications allowed the pair, with their plethora of aliases, to continually be caught but freed on bond. The ability to cross-reference would prove an important one in crime fighting.

The *Evening Reporter Star* published an article on the Hunt-Gant gang as a front-page story on Tuesday, February 18, 1930. The article, titled "Police think Auto Theft Gang broken," preceded three subtitles—"Seven Arrests Here Yesterday Thought Part of State Ring," "FEDERAL MEN COMING" and "Knife Fight Among Members of Group leads to Detection." Orlando police believed that a statewide ring of "notorious auto thieves, operating in many Florida cities for the past six months" was being rounded up. Five men and two women were arrested. Two of those who were arrested, Hunt and Riley Gant, were wanted in Tampa and West Palm Beach for suspicion of earlier automobile thefts. This is suggestive of an early pairing of Hunt and Riley in Jacksonville and other points throughout the state. Others arrested included Truby Hunt, William F. Kelly, Weyman Verble, Thelma Gant and Inell Jackson.

The group was rounded up after Kelly was arrested on a Sunday evening for a fight that night in a home on the outskirts of the city that they had rented several weeks previous. Kelly claimed that other members of the gang had double-crossed him, so Kelly attacked two of them with a knife. He was held for questioning and investigation and led Police Chief Pope and Lieutenant George Coston to be convinced that the information they had gleaned detailed the operations of the gang that federal investigators

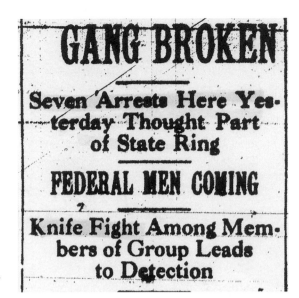

GANG BROKEN

Seven Arrests Here Yesterday Thought Part of State Ring

FEDERAL MEN COMING

Knife Fight Among Members of Group Leads to Detection

Proof of the knife fight that ended the Hunt-Gant automobile theft ring. (*The Evening Reporter Star*, February 18, 1930)

had been tracking the previous six months. Kelly confessed that the group had been operating for several months in many Florida cities. The ring targeted new Fords, Chevrolets and Buicks and then sent them to Georgia and Alabama where the serial and motor numbers were changed, the bodies repainted and stolen Alabama license plates attached. The vehicles were given counterfeit certificates of title and a fake Alabama state seal and then were transported back to Florida for resale.

Police confiscated an array of weapons on the premises, including sawed-off shotguns, two German Lugers with silencers and a set of burglar tools, "delicate instruments used for removing locks from Ford" vehicles and a number of substitute locks with matching keys. Federal officers were notified and were said to be making their way to Orlando. Interestingly a recent "wholesale arrest" of car thieves in Pensacola, Florida, had included Mrs. Ada Weir. Police stated that Mrs. Weir was the wife of one of the men arrested in Orlando. She made $2,500 bond after being arraigned.

Lieutenant Coston believed that those arrested in Orlando were connected with the Pensacola robberies and with bills of sale for many of the Florida cars that were being forged in Tampa. He added that forty-nine cars had recently been recovered in northern Florida, fourteen of which were positively identified as having been stolen in Florida and previously warehoused in a barn in southern Georgia. Coston stated, "I believe every car theft in Florida in the last five months not cleared up will be traced to the operations of this gang." He was confident that with the apprehension of all the members of the gang that "this organized business of stealing cars will be stopped."

Gant's first marriage
certificate to a probable
accomplice.

The *Evening Reporter Star* followed up with an article on February 27, 1930, about further car recoveries. Two vehicles that had been stolen from Orlando were recovered in the "aftermath of the roundup of auto thieves" by Orlando Police. Lieutenant Coston was credited for conducting the major part of the investigation. A Ford coupe belonging to Orlando high school Principal J.B. Walker as well as Mrs. Lydia M. Carter's car were both returned.

Docket one, case number 94 listed Hunt, Dewey, et al for a 1927 felony. The Order of the Court stated that the "petitioner was convicted of a felony" and that bond was set at $2,000. The petitioner "tendered to the Clerk of the Court" a bond executed by the Lexington Surety and Indemnity Company of New York. The act was done in court at Kissimmee, Florida. An answer was returned to the respondent regarding a writ of habeas corpus. Floyd Miller (alias David Carson), Hugh Gant (who did not give his name and was tagged John Doe) and Pete Collins (alias L.M. Collins) were tried with Hunt for the November 1927 crime. They all plead not guilty for the theft of a Cadillac sedan, five-passenger automobile valued at $3,000 and owned by J.A. Griffin. The group was charged with buying, receiving, concealing and aiding in the concealment of the vehicle. On February 16, 1928, the jury announced, "we the jury find Floyd Miller and Pete Collins not guilty."

Petitioner Truby Hunt, aided by attorneys Elmer R. Jones and a Mr. Green, launched an action of habeas corpus against Chief of Police L.G. Pope. Accomplices Idell Jackson, Raymond Verbal, Riley Gant and Thelma Wilson followed suit. Thelma Wilson was listed alternately as Thelma Parham, Pachon, Fields and Gant. Many of the names may have included clerical mistakes but it is likely that one or more were aliases. Hugh Gant had married Thelma Fields on June 29, 1923. The feds listed the marriage

as having taken place in Bushton, Florida, while documents suggest that it took place in Sumter County and, therefore, most likely they meant Bushnell. They divorced in 1930, possibly after this brush with the law.

On February 25, 1930, Truby appeared in court before Judge Frank A. Smith. His petition was discharged. Then the lawyers asked for an order for dismissal on February 26, 1930, claiming "unlawful imprisonment…without any warranty or authority of law."

Hunt and Gant operated separately at times, fulfilling their own needs and preferences. It was documented by the Federal Bureau of Investigation that Gant was comfortable in cities while Hunt preferred the country. Gant's last name was confused for Grant once more, this time in the Record of State Prisoners for the years 1927–1931. It lists prisoner number 20688, Hugh Grant, alias E. Sparkman, in reference to his May 10, 1929 arrest in West Palm Beach for breaking and entering.

Gant received two years for receipt of stolen goods, E.M. Coleman's Ford sedan, and was sentenced on July 23, 1929, to Raiford State Prison. On November 14, 1930, Gant was presented for parole and was denied. He received a conditional pardon and was freed December 4, 1930. The conditional pardon came courtesy of recommendations from the prison superintendent and other prison officials, a letter from the Honorable J.C.B. Koonce, a personal recommendation from Miss Thelma Hunt and an allusion to Gant's father possibly battling cancer may have played a role in his pardon. Gant had previously been Florida prisoner number 24805.

Between his release and his next run-in with the law Gant found time to marry again. Ida Lee Burke, listed as Ida Bushe by the FBI, and Gant married on January 14, 1932, in Inverness, Florida, in Citrus County. The marriage was certified in Haines City. Little is known about the marriage. What is known is that Ida initiated and received a divorce from Gant. She later died in an automobile accident.

Meanwhile, Hunt was back in Orlando, a familiar haunt, and pursuing another automobile theft. On February 16, 1930, he was again arrested and sentenced to sixty days in the city workhouse. His luck later ran out when Sheriff Frank Karel was called to Bronson, Florida, and brought Hunt, operating as Davis again, to Orlando from Levy County to face charges in connection with a theft of 1,300 small cartons of cigarettes from the O'Berry Hall Warehouse. According to the *Evening Reporter Star* a Ford truck was stolen that possibly contained the cigarettes. At the time of his arrest Hunt was in possession of 260 cartons of cigarettes. He sold 15 cartons to a man named Peak, of Gulf Hammock, Florida, at one dollar per carton. An alleged accomplice named Wilkinson was taken with Davis but escaped Levy County officers in a gun battle and was still being sought.

Fingerprints revealed Davis to be Alva D. Hunt, "member of the notorious auto theft ring known throughout Central Florida." Hunt was identified by prints taken in 1930 when Orlando police broke up the Hunt auto ring, and he was wanted in two other parts of Florida on similar counts. Hunt received his one-year, one-day federal term in the Atlanta penitentiary. The *Orlando Morning Sentinel*'s article, "Theft Suspect Confesses Here," stated that Hunt was confronted by fingerprints and an old picture from the Orange County rogues gallery. He confessed that he was Alva Hunt, "brother of Truby Hunt" and member of the auto theft ring.

The *Evening Reporter Star* printed an article on April 4, 1932, titled, "Suspect Identified as Member of Hunt Gang." It is interesting to note that the gang evolved from a nameless consortium under the direction of Riley Gant into the auto theft ring known as the Hunt Gang. Later it morphed again after the dramatic switch that Alva Hunt and Hugh Gant made from vehicle thefts to bank heists. The story stated that George Davis's true identity had been uncovered by county fingerprint expert J.C. Stone.

The Orlando Police Department, along with most police forces in sizable cities throughout the United States, was modernizing. By the mid-1920s Orlando had added anthropometry to its stock of identification techniques. Better known as the Bertillon System, anthropometry was a technique developed by French criminalist Alphonse Bertillon. It involved precision measurements of individuals' anatomies for future comparisons. The Bertillon System was complicated and time-consuming, yet it was initially

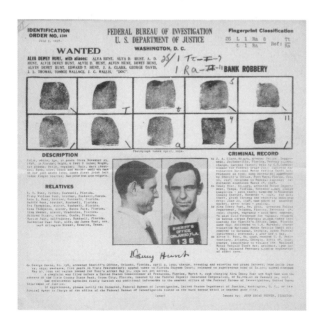

Alva Dewey Hunt's Federal Identification Order.

the accepted means of criminal identification. Fingerprint identification eliminated what swiftly became an archaic means of classifying criminals.

Hunt had been arrested on April 2 for breaking and entering. He was arraigned on June 26, 1932, in Bartow, Florida, and was simultaneously wanted by the Tampa Police Department as a Dyer Act fugitive. The Dyer Act, also known as the National Motor Vehicle Theft Act, was passed in October of 1919. It gave feds the ability to prosecute criminals who previously evaded law enforcement by crossing state lines. A.D. Hunt, operating under the alias George Davis, launched an action for habeas corpus versus Sheriff Frank Karel on August 11, 1932. Hunt was sentenced five years but was released later on an appeal to the Florida Supreme Court on a supersedeas bond of $2,500. The appeal was later dismissed and a new warrant for his capture was issued. But by then Hunt was free.

Karel served two stints as Orlando sheriff—January 4, 1921, to January 3, 1933, and then from 1937 to 1941. Between terms he served as chief of police in Orlando. Under his administration J.C. Stone created the first fingerprint section for the Orange County Sheriff's Department. In the department's *150th Anniversary History Book*, David S. Starr, who later became sheriff and served as a deputy under Karel said, "We had murders back then, and stills…you talk about moonshine."

Atlanta's prison was a repository for many of the nation's hardcore and unrepentant prisoners. The penitentiary was described as hot and claustrophobic and the prison population was "swollen with bootleggers," most of whom were from rural areas in the South. Danger lurked in the crowded jailhouse. "Every man had a long knife or a blackjack. Such weapons were plentiful in Atlanta at the time" when Hunt was housed there. Charges of corruption regarding Atlanta's guards flowed upward to include even Warden Aderhold. Hunt was released on February 5, 1931, courtesy of the accumulation of short time.

The number one Atlanta prisoner at the time was Alphonse Capone, Atlanta Penitentiary number 40886. Courtney Ryley Cooper later wrote about Capone's stays in Atlanta in *Here's to Crime*, one of his two books about his time with the FBI.

In Atlanta, there was Al Capone, who remained Al Capone in spite of his number, in spite of his sentence. Whatever Al Capone thought was the ultimate to other convicts. How he looked when he appeared in the mess hall, how he acted, what he said out of a corner of his mouth, how much food he ate, how he winked at someone as he passed—these were vital factors of convict news. The Atlanta world revolved about Al Capone. He was the man who had been able to make crime pay. Everybody knew he

This writ certified the beginning of a long-standing relationship between Hunt and Orlando Police Sheriff Karel.

had money hidden away somewhere; what if he did have to spend a few years behind bars? He'd get out, and he'd live in riches forever. It was a lucky fellow who could be an Al Capone.

Few could be such a man and even Capone's reign was not long-lived.

Gant remained active, too. On November 15, 1931, Gant with "force and arms" stole a Chevrolet sedan valued at $725. The vehicle was owned by J. Hartwell Jones. In addition, Gant "unlawfully and feloniously" bought, received, concealed and aided in the concealment of the automobile. A warrant was executed on February 25, 1932, to locate Gant. A bond fixed at $5,000 was received in August of 1932 when Gant was arrested in Deland for theft of merchandise. He was delivered to Hillsborough County to face the automobile theft charges.

Finally the trial was set for November 16, 1932, the *State of Florida, County of Hillsborough versus Hugh Gant*. Gant was charged with larceny of an automobile and receiving stolen property. Witnesses were subpoenaed, including Eloise Baker from Eustis, Bill Burke at the state prison, Viola Burke and J. Hartwell Jones of Tampa, T.M. Chevis and D.D. Stephens from the Tampa Police Department and Jim Linville. Gant's attorneys attempted to quash the case stating that the information was "duplicitous" because Gant was charged with both stealing and buying the same automobile on the same day and that the information presented was vague. A motion for a new trial was denied and Gant pleaded guilty to the second count of receiving and in turn received a judgment of three years at Raiford minus three months and five days of time credited.

On the night of April 24, 1933, a state highway engineer drove a truck into the prison camp near Homosassa. He was met at the gate by a convict armed with a rifle and two others armed with pistols. The convicts kidnapped the engineer, took the truck and drove toward Tampa. The engineer was released at West Cass Street and Albany Avenue. The truck was found at Morgan and Whiting Streets two hours after the engineer was recovered. The identities of Gant's accomplices in the escape remain unknown.

Gant's daring escape bought him temporary freedom until his arrest on September 6, 1933, in Geneva, Alabama. He was employing the alias Harry A. Smith and was being held for violation of the Volstead Act, though unknown to law enforcement Gant was free due to the escape. Gant was released on bond and arraigned by federal prohibition agents, but "Smith" did not appear in the Mobile, Alabama court, opting to forfeit the bond.

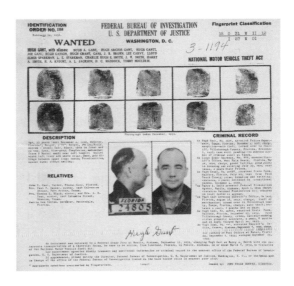

Hugh Archer Gant's Federal Identification Order.

Graduation to Bank Thefts

Events took a dramatic turn on August 14, 1933. Both Hunt and Gant were by that point fairly hardened criminals with a long list of attempted and successful automobile thefts and store robberies. A poignant event shook the two as surely as it altered the leadership dynamic of the gang when a late-night breaking and entering into a store ended in a shootout and the death of the gang's titular leader.

A *Florida Times Union* story dated Thursday, August 17, 1933, was titled "Slain Robber, John Riley Gant Jr. Had Home at Webster, Fla." The story stated that the "nightwatchman slayed a robber at a Penny Farms, Florida store early Monday morning." The body was identified at the Burns-Howard Funeral Home. Local police first identified the deceased as John Edwards. Edwards was Riley Gant's alias and he was attributed a long criminal record. The night watchman, W.H. Sunnersill, apparently waited outside until the "trio pillaged" the premises and exited. Sunnersill then fired at Gant, presumably Riley, as he allegedly went for his gun. Two accomplices fled on foot leaving the loot they had stolen and the automobile in which they hoped to escape. Sunnersill claimed to have possibly hit one of the fleeing robbers. Gant's hometown newspaper, the *Sumter County Times*, ran a story shortly thereafter that was a synopsis of the *Times Union* story.

A separate event involved a Truly Hunt, age twenty-five, who was arrested and sentenced to one year for committing larceny of an automobile in nearby Lake County. He was sentenced on May 18, 1933, and released on conditional pardon in December 17, 1933. His prison number was 25254.

The gang's direction changed probably as a reaction to the demise of their automobile theft ring and certainly in part due to Riley's death. A lull in operations occurred, perhaps to quell the unease they felt over

Riley's death or to examine their experiences with recent incarcerations and escapes. Perhaps the pair went underground to plan for a new level of crime. Whatever the cause of the gap between their early and later crime spree, Hunt and Gant reemerged and escalated their crime to a new level.

During the lull, law enforcement continued to pursue them. A reward poster from the Post Office Department, Office of the Inspector in Charge, in Atlanta, Georgia, was dated August 27, 1934. In it Gant's last known whereabouts were given as Crofton, Kentucky. The poster noted that Gant, under the alias A.L. Jackson, and his wife were operating a filling station and sandwich shop. He may have known that the heat was on because he left Crofton hurriedly, ten days previous to the publication of the poster, fleeing in a maroon, 1934 Chevrolet standard coach. The vehicle had serial number 8DC02-1-1 and motor number M43019. Gant held a Christian County, Kentucky driver's license, with number 148423. At the time he also possessed a Florida license numbered 172941.

The post office inspector noted that Gant was under indictment in the Northern District of Florida for the burglary of the post office at Baker, Florida, on September 5, 1933. He was implicated in several other Florida post office jobs, including Floral City, Sparr and Tampashores.

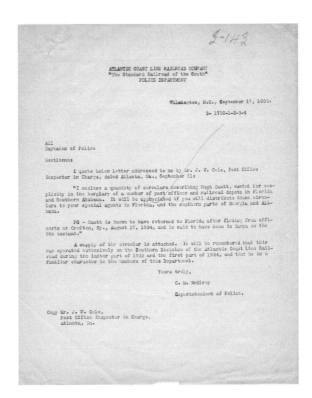

The Atlantic Coast Line Railroad published a bulletin on the whereabouts of Gant as he was "known" to have burglarized a number of railroad depots.

The inspector suggested that Gant was under indictment for a bank heist at Cedar Keys that occurred on February 7, 1934, and was thought to be involved in bank robberies at Orange City, Florida, in October of 1933 and St. Cloud, Florida, in March of 1934. A reward was offered, not to exceed $200 for information leading to his arrest.

The Atlantic Coast Line Railroad Company Police Department, headquartered in Wilmington, North Carolina, sent out circulars to all captains of police. They quoted a letter addressed to C.M. McElroy, superintendent of police, which stated that a quantity of circulars regarding "Hugh Gantt, wanted for complicity in the burglary of post offices and railroad depots in Florida and Southern Alabama" had been distributed.

A postscript added, "Gant is known to have returned to Florida after fleeing from officers at Crofton, Kentucky." It stated that he was in Tampa and offered that "this man operated extensively on the Southern Division of the Atlantic Coast Line Railroad during the latter part of 1933 and the first part of 1934" and that he was a familiar character to members of the railroad department.

On September 5, 1935, the pair was officially charged with breaking and entering into a post office in Baker, Florida. Whether it was the town of Baker or Baker County is undeterminable. The post office inspector from Chattanooga, Tennessee, charged them with the break-in. The next day Hugh Gant was arrested in Geneva, Alabama, for automobile theft and was held for that crime and for the alleged post office theft. On September 23 after a three-week stay, Gant and five other prisoners broke out of the Geneva jail and escaped.

The pair's probable connections in protected cities, most certainly gained while in jail, may have led them to meet another crime combine, part of which vacationed in Ocklawaha, Florida. Like today, all types of people were drawn to Florida's warmth and the opportunity for a second chance. Among the masses that thronged to Florida were gangsters. In addition to Ma Barker and her connections, Dillinger and his crew, Al Capone and others visited the Sunshine State.

According to Hunt's niece Inez McMillan, his connections at home included the Sumter County sheriff, among others. It is more suggestive of the folksy lifestyle of the county rather than a suggestion of impropriety of the police force. There are also indications that Hunt returned to Sumter County incognito numerous times.

Hunt and Gant's numerous travels throughout Florida and across the Gulf States and their use of "protected cities" may have put them in similar circles with some of the Barker contingent. Protected cities included St. Paul, Minnesota; Toledo, Ohio; Kansas City, Kansas; and Fort Worth,

Galveston, San Antonio and Houston, Texas. The last played host to several prominent events in the lives of Hunt and Gant. According to gangster extraordinaire Eddie Bentz "some towns are only good for a year or two," while others lasted a decade or more. Protected cities were for cooling off, and therefore, it was recommended that bank-robbing crews should choose a town at least three or four hundred miles away.

Just weeks before what was probably the first Hunt-Gant heist, Ma and Fred Barker had taken up residence in a cottage in Ocklawaha near Lake Weir, twelve miles south of Ocala. Visitors to the cottage included gangsters Bryan Bolton, Alvin Karpis, Willie Henderson, Harry Campbell and a paramour named Wynona Burdette. The feds were alerted to the whereabouts of the Barkers when they found a map, with the Ocala and Lake Weir area circled on it, in a Chicago apartment. Bolton, under federal lock and key corroborated the evidence and confirmed that they were in that part of Florida. Doc Barker and Russell Gibson had scouted the area out ahead of time and even found time for fun. The story went that they had tried to catch an alligator named Old Joe by placing a pig in a barrel. The barrel was hooked to a line to entice Joe close enough so Doc and Russell could kill it. The gator, according to legend, got the pig and escaped.

The abbreviated Barker vacation that started January 8, 1935, ended on the 16th, the result of a coordinated FBI operation. While no verifiable proof exists showing a relationship between Hunt-Gant and the Barkers, similarity in profession, connections and geography suggest the possibility. Ma Barker was alleged to have even stayed at the St. Cloud Hotel, providing further suggestive evidence that she was familiar with the central Florida area.

Sumter County Sheriff's Deputy Ed Williams spoke about the Barkers and their possible relationship to Sumter County. Deputy Williams and his son were present at Wall Sink while Lake County search divers sought to recover two bodies. While diving they recovered two older vehicles. One, according to Williams, was a circa 1949 Ford. The other, a 1930s Dodge Brothers touring car, allegedly belonged to Ma Barker and the boys. If correct the Barkers may have had an intimate familiarity with the county since the sinkhole is not easy to access in its nestled Sumter County location.

On November 14, 1934, Hunt and Gant "tested the waters," successfully robbing their first bank. The "haul" from the Bank of Mulberry was initially thought to have been between $4,000 and $5,000, while a detailed check of the bank's records showed a loss of $7,180—$500 in twenty-dollar denominations, $1,500 in tens, $2,000 in fives and $1,950 in singles. Also included in the haul were mutilated bills totaling $430, $70 in half dollars, $230 in quarters, $260 in dimes, $210 in nickels and even $30 in pennies. Prudently the loss was covered by insurance.

The injection of confidence that they could "pull" further jobs bolstered a furious stream of robbery attempts. *Polk County Record* printed a story titled "Three Bandits Rob Mulberry Bank, Shove Cashier off at Christina In Escape." The robbery unfolded around 1:15 p.m. with the three robbers hauling nearly $10,000 and hostage A.D. Denham, a bank cashier. The trio's escape vehicle was a 1932 black Plymouth sedan with yellow wheels. The car drove in front of the bank while one of the gang "remained under the wheel with the motor running." The other two entered the bank, drew guns and aimed them at the bank's employees. Then they forced Luther Pipkin and W.G. Overstree into a back office where they were forced to lay down on their faces. Denham was then forced toward the vault to secure the loot and made to carry it to the awaiting car. After he placed the haul in the car Denham was compelled to ride the running board. As the car neared a former mining town named Christina, he was pushed off. A passing car eventually picked Denham up and returned him, unscathed, to Mulberry.

Two citizens standing outside the bank during the theft were heard to mention, "It looks like a hold-up." Since neither man was armed there was no attempt to foul the robbery attempt. The sheriff's office was notified and an alarm was sent out "in all directions," though the bank bandits were last seen heading north. Witnesses claimed that the two who entered the bank wore white gloves and dark clothes, the former explaining a lack of their fingerprints in the bank.

The following day's *Polk County Record* stated that suspects in the robbery had been arrested in the Willow Oak section of town by Constable Whidden and were being held for investigation. One suspect was an elderly man who only arrived to the area from Illinois a few days before the bank heist. He and Fred Porter arrived together. W.O. Oscar Guerin, age fifty-five, and his son B.A. Burt Guerin, age twenty-three, were being held as well. At the time of the arrests none of the money was recovered. Burt was reported to have been in Polk County for about one month before the crime. Hugh Gant who "escaped the state penitentiary on April 24, 1933," emerged as the possible engineer of the bank heist according to law enforcement.

A clue in the case regarded the vehicle used in the robbery. A new 1934 V-8 Ford sedan belonging to Dan Lassiter had been stolen from a parking lot on Lemon Street in Lakeland, Florida, the night before the robbery. Hugh Gant was thought to have been rooming several weeks prior to the first robbery in a home in Hopewell, Florida, south of Plant City. Generally Hunt and Gant preferred to take a car several weeks in advance of the bank robbery and usually made sure there was considerable distance between the location of the car and bank robbery. The Lakeland theft did not fit their modus operandi.

The next day the paper revealed that another of the prisoners, Fred Porter, was being released. The two original suspects, W.O. and Burt Guerin, were taken to Bartow to be held in the county jail. Fingerprints were taken from the suspects and were sent to the Department of Justice to check for a criminal past. The Guerins were exonerated the following day as information from various sources corroborated their innocence in both Mulberry robberies. W.O. Guerin was charged with operating an automobile with an improper license tag.

The days revealed more clues to the crime. Deputies from a sheriff's office in Brooksville, Florida, substantiated that a sedan was stolen on November 10 from R.R. Rayburn, a St. Petersburg grocer. His was the vehicle used in the Mulberry bank heist, not Lassiter's. Remnants of a vehicle matching the description of the one used were found near Brooksville according to Chief of Police Noel. The car had been set afire, which was the known mode of operation of Hunt and Gant when they dumped their vehicles.

With only a possible connection to the vehicle used, Sheriff Chase of Mulberry took out warrants for the bank holdup and for assault on cashier Denham with a pistol and intent to murder. Sheriffs Chase and Bill Mock and Federal Post Office Inspector Frank Sanford of Lakeland made a trip two weeks later to interrogate a J.C. Smith. Smith had confessed to robbing Seaboard Air Line mail sacks from the train at Okeechobee, Florida. He also claimed to know of more robberies and bragged about his involvement in a number of Hunt-Gant crimes. Smith's information proved to be scanty or inaccurate.

After a three-month gap in activity the outfit "hit" another bank. On February 28, 1935, Hunt, Gant and unknown accomplices robbed a bank in Haines City, Florida. It was their second *recorded* heist and rewarded them over $4,000.

Just over one month later, on May 3, they were accused of breaking and entering a warehouse in St. Petersburg, Florida, and stealing an automobile. The 1935 Buick, or similar model, was used in the Bowling Green, Florida bank job that occurred two weeks later, on May 17. Interestingly, while the FBI, law enforcement and countless newspaper stories foisted the Bowling Green robbery on Hunt and Gant, there are no details of their involvement or mention of the amount of money taken.

On August 1, 1935, the pair was alleged to have stolen a vehicle in St. Augustine, Florida. The car, a Ford coach, was possibly the one used in another robbery of the bank in Mulberry, Florida, though they would have had to steal the car almost as an afterthought. The next day they robbed the Bank of Mulberry, again.

In a *Mulberry Press* story titled "Robbers Stage Comeback, Visit at Mulberry Bank," it was said that "three masked men, believed to be the

same gang" that robbed the bank on November 14, 1934, visited on Friday afternoon for a repeat performance. The less-than-successful heist netted only $400.

During the second heist, C.B. Mansfield had just completed business at the cashier's window. As he turned to leave three men entered and jabbed a gun toward him. They told him to stay a while and to lie down on the floor. Luther N. Pipkin, in the cage next door to cashier A.D. Denham "sensed a return visit." Pipkin declared that he recognized one of the robbers as the man "who covered him and W.G. Overstreet" during the first robbery. He pressed his foot on a burglar alarm and awaited the robbers' commands. The second crook stuck a gun through the window while Denham made busy in the cash drawer. The third accomplice stood out from the others because he was wearing a white wig made from "tow string" and white gloves. He entered the office and ordered Denham to open the vault.

Meanwhile, as Pipkin and Mansfield lay on the floor, Denham tried to explain that he could not open the vault because it had a time lock. The third robber (the one in white wig and gloves) did not believe Denham and they had a brief argument, which ended with the robber striking Denham on the back of the head, later said to have produced a "popping" sound. Denham fell and stayed down. Just then the bank phone rang and the alarm sounded in a downtown store. Nearly fifty citizens ran to Polk Avenue by way of Main Street and watched the proceedings from a safe distance.

Deputies Childs and Mock arrived, covering the eight and a half miles quickly, but trailing the robbers by about one minute. Unlike the frenetic and harried arrival of the crowd of onlookers, and later the deputies, the robbers had made a leisurely emergence from the bank and got into their getaway car. Black and badly mud-stained, its Florida license read 198-701. The car got up to full speed at Church Street heading in the general direction of Lakeland. The crooks sped around a corner near the Juanita Hotel nearly plowing down Robert Caldwell Jr., who was on his bicycle.

Mulberry citizen Harold Clark was driving to the bank with two representatives of the Standard Oil Company from Lakeland as the getaway car whizzed by. Clark turned his car and gave immediate chase in his V-8 Ford. Close behind was Fred Marsh, a man named Leonard and another named Cardwell. Others joined in the pursuit in additional cars. The chase was furious as the criminals and their pursuers bounded out of town and into less-populated areas. However, the robbers proved to be a step ahead of their pursuers, thanks in part to having a well-prepared git. As was the case with other bank robbers of the period, the Mulberry bandits used a "blind" to confuse witnesses and draw attention from the real escaping vehicle. An additional driver would speed away in the blind car hoping to lure law

enforcement in a false direction and create incorrect reports from honest citizens. A second car was later found waiting between Mulberry and the town of Medulla, and various reports of a "man in a white wig" driving at the breakneck speeds of fifty to sixty miles per hour trickled into the police department. An unnamed woman reported seeing a white-haired man pass by in a car from her front porch before the bank heist.

The robbers were identified by cashiers from the Haines City and Bank of Bowling Green jobs that had been struck between the first and second Mulberry heists. The tactics were essentially the same in each of the four robberies. Government operatives announced that suspect Thomas Bradley Shaw, believed to have been involved in both Bank of Mulberry robberies, and Hugh Gant had been positively identified through rogue's gallery photographs. Shaw, said to have been living in Mulberry for several months prior to the first heist, was believed to have been involved with Gant in other jobs as well. G-men arrested Shaw in Dothan, Alabama, and charged him with violation of the Mann Act.

The Mann Act, known colloquially as the White Slave Act, was passed in June of 1910, the result of a phenomenon known as the White Slave Scare. The theme of the scare was that prostitutes and their pimps were in the process of taking over the country and that even genteel women were not safe. The act made it illegal to transport women across state lines for immoral purposes. In addition, and more significantly from a law enforcement perspective, it allowed the federal government to investigate criminals who continually evaded state laws but had accrued no federal violations.

Shaw was being held and was going to be tried in a federal court in Pensacola. Sheriff Chase took bank officials from Mulberry as well as Haines City to Pensacola to make the identification. An affirmative identification for the first Mulberry heist was made and left Shaw with a $10,000 bail note and the promise of a long sentence of incarceration.

One year later the *Mulberry Press* ran a story touting the Bank of Mulberry's improved protection. Workmen were engaged in installing bulletproof glass with the aim of discouraging future robberies. The glass was installed in all of the outside windows and the cages fronting the main lobby. "Suitable potholes" were provided at intervals, through which the cashiers could "take a potshot or two on their own account." An article highlighting the year in review dated January 2, 1936, related the second Mulberry robbery and boasted that Shaw had been convicted and sentenced to five years on federal charges.

On January 14, 1936, Hunt and Gant pulled another job. This time they scored $4,000 by robbing the Dixie County State Bank in Cross City, Florida. During the robbery, Gant struck cashier B.S. Preston Sr. over the

head with a gun and "assaulted" W.M. Mullin, a customer. Hunt and Gant fled in a stolen Graham sedan and had a rear tire shot out during the escape. Forced to abandon the disabled vehicle Gant accosted a young man using a "clubbed rifle." The pair forced two youths and a lady friend out of their Ford Model A and continued their escape. By this time Gant had especially earned the reputation for being a "desperate criminal" who was always armed and inclined toward violence.

Hunt and Gant had the assistance of known accomplice Jack Ray Oliver. On July 1, 1936, Sheriff J.R. McLeod of Tampa had sent notice that he had arrested Oliver on June 27, along with Louis Marenco.

Marenco, who had been on parole for six months, was born around 1913, the son of an Italian immigrant plumber. The twenty-two-year-old had been sentenced in Alachua County to four years for attempted breaking and entering on May 16, 1935, and given prisoner number 27508. Any previous involvement with Jack Ray Oliver and how he became involved with the trio is unknown.

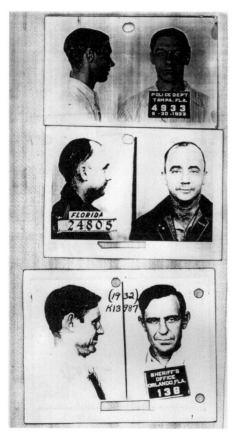

Louis Marenco, probable accomplice, is pictured with Hunt and Gant.

At the time of the arrest Oliver and Marenco were armed with two pistols and two shotguns and driving a vehicle with improper plates. They admitted that their intention was to hold up a truck loaded with cigarettes en route from Jacksonville to Tampa and were held until their release on habeas corpus on April 6, 1937, with the intention of returning to court later that year.

On December 14, 1937, indictments were passed for Jack Ray Oliver, an accomplice in the Cross City heist. Ray Oliver had previously received a conditional pardon on a five-year sentence at Raiford for breaking and entering. The target had been the OK Candy Company on December 5, 1934. On April 24, 1935, the pardon granted on March 19, 1935, was revoked. Oliver, then twenty-five years old and operating under prison number 26393, was given a second number, 28899, when the conditional pardon was revoked.

On December 14, 1937, Oliver plead not guilty, part of the criminal docket number 665, the *United States versus Hugh Gant, Alva Dewey Hunt, Jack Ray Oliver and Benjamin Alvarez*. A commitment was issued the same day and was returned on December 22. Oliver then began his twenty-year sentence in Atlanta for bank robbery.

For *United States versus Hugh Gant, with aliases and Jack Ray Oliver, with aliases, et al* on the violation of the National Motor Vehicle Theft Act, Oliver was moved from the county jail in Milton, Santa Rose County, Florida, to similar accommodations in Quincy. U.S. Marshal E.M. Sessoms transferred him two days later from the Leon County Jail in Tallahassee to the Gadsden County Jail.

Hunt and Gant's most daring and successful bank heist took place in Ybor City, a suburb of Tampa, Florida. It was a change in type of venue from their five previous smaller, rural bank robberies and correspondingly yielded a larger take. According to the *Tampa Times*, dated March 3, 1936, "Bank Bandits get $25,000 Here." The "here" was the Columbia Bank on East Broadway and Twenty-first Street, and the "bandits" were five armed, well-dressed, unmasked men.

Shortly after eleven o'clock in the morning, officers spread out to cover a wide search area. It was reported at 11:14 a.m. that the getaway "high powered car" fled south on Twenty-first Street, headed for Fourth Street and turned east fleeing toward Plant City. Another report added that the vehicle then turned north on Thirty-sixth Street making its way toward Seventh Avenue. Yet another report had them at Six Mile Creek, while a fourth had them turning North at Fortieth Street.

Considering the varied reports, perhaps frenzied citizens were seeing things, or maybe the "complex cordon around road arteries and thoroughfares forced the five to speed and careen through Tampa in order to escape and

GANG OF FIVE GETS $26,309 IN YBOR CITY BANK HOLDUP

Daring Daylight Robbery Baffling to Law Officers

COLUMBIA RAID IS STAGED BY FIVE ARMED MEN

Unmasked Robbers Force Employes, Customer to Lie on Floor

QUICKLY ESCAPE

Vault Opened After Hold-up Men Kick Prone Victims

Left: The *Tampa Tribune* banner headline drew attention to Hunt, Gant and the rest of the gang. (*Tampa Tribune*, March 4, 1936)

Right: The *Tampa Times* suggested that the gang resorted to violence during the raid. (*Tampa Times*, March 3, 1936)

to cover their tracks." However, what became evident as the days moved on was that the escape was timed with the "precision of an artillery barrage." Police officers even credited the robbers for their finesse, for probably not traveling too far from the scene of the crime and for evading being positively spotted.

Officers admitted that there was a possibility that a nearby hideout existed where the quintet may have changed vehicles. They went on to say that the robberies had the markings of professional bandits and they were well aware of Hunt and Gant's modus operandi of using a stolen car for the initial escape and abandoning or burning the vehicle shortly after a heist. According to the *Tampa Morning Tribune* on March 10, the robbery "technique developed to such a point that whenever a bank robbery" with that format occurred, the cry "Get Gant!" went out.

In 1927, Columbia Bank's president was ironically a previous victim of the Hunt-Gant automobile ring when his five-passenger, Cadillac sedan automobile was stolen. Bank President J.A. Griffin reported that the holdup was the first in Tampa since 1930 and that the money was covered by insurance. Vice-president George Simpson said, "As I started to get up I

saw four men walk into the bank and go through my little office. They told us they were holding us up." Later Simpson was kicked when told he was "holding out."

According to Simpson one robber took position at the front door, another stood in the door leading to the section of the bank where the employees worked and two others began to loot the bank. One of the bank employees, cashier R.H. McKinney, had a pistol poked in his back and was forced to open the door to the vault. He was coerced into pouring the money and bank papers that later proved worthless into "two rag sacks." The fifth accomplice waited nearby in a V-8 Ford sedan.

Witnesses were unanimous in stating that the robbers were quick and alert. The police initially broadcast descriptions of three of the robbers and said the vehicle used in the daring escape was a V-8 Ford sedan that was blue or green in color. The last two numbers of the license plate were 79, and police ventured at the time that the car was stolen in Miami. Witnesses were unanimous in their description of the Ford as blue and agreed that it was new—either a '35 or '36 model. Some differences of opinion regarding its styling did emerge as several onlookers professed that the vehicle was a sedan, while others called it a coach. Witnesses and bank employees thought that the whole procedure took four to five minutes. Some later offered conjecture that the bandits had watched the bank until area foot patrolman Dennison finished his first beat, called in a report and started a second beat. Then the quintet hit the bank.

A bookkeeper named Tom Passaron, who was kicked several times for not answering questions from one of the thieves regarding the location of the vault's key, and John H. Shea, an adding machine repairman, got up to follow the robbers. They armed themselves with pistols and sped toward Plant City, hoping to catch up with the bandits. Customer Mick Alban joined the pair in what turned out to be a fruitless pursuit. John Lazzaro, a teller, was in the bank during the crime while bookkeeper Henry Scaglione was absent, having gone to the Latin American Bank.

About the same time that Passaron and Shea were bolting after the crooks, Lieutenant Edding, in a radio patrol car on Fourth Avenue near Fifteenth Street, heard the report that the bank had been robbed. Edding rushed east on Fourth Street toward Riverview in the general direction of Bradenton, Florida. He was unable to glimpse the bandit's car. Federal officials were called immediately to join City Detectives Yates, Sinclair, Abramowitz, Shinn, Vance, Dunn, Henley and Shykove in the investigation. The scope and daring of the crime merited help from Sergeant Murrell of the city's Identification Bureau, several county investigators, Sheriff Logan, Deputies Vestal, Hancock, Rosse and DiLorenzo and Constable Fernandez.

The next day, the *Tampa Times* noted that the bandits had thus far eluded capture and that no fingerprints were left since the bandits did their work with gloves. Though there were leads and the police maintained an optimistic public face, comments made in confidence suggested that solving the crime was going to be difficult. At least one of the bandits had been identified by a Columbia Bank employee from a picture. That bandit was Hugh Gant, called an "ex-convict" and the gang's leader. Hunt's role as leader may have diminished as the gang evolved from a car theft ring to a bank robbing one, as it shifted from crimes of finesse to crimes that, at times, required aggression and violence. According to the story, police departments throughout the South had joined forces in an "extensive search for the five unmasked, armed bandits." Details of the robbery revealed that the haul was $24,809.81 in cash, government bonds totaling $1,500 and even $500 worth of traveler's checks that the bandits could not transfer and were therefore worthless. They left behind approximately $12,000 in silver coin.

The day after the heist Chief Deputy Logan took charge of the county's side of the investigation with the aid of Sheriff McLeod while Chief Bush and the Head of Detectives M.C. Beasley worked from the city's angle.

Where Gangsters Looted Ybor City Bank

Bank employees calculate the tally of losses incurred by the robbery. (*Tampa Tribune*, March 4, 1936)

The latter pair claimed to be working several leads, though off the record they acknowledged that the robbery had been carefully planned by "master criminals" who planned with minute attention.

Not to be outdone in the battle of the city newspapers, the *Tampa Tribune*'s March 4 edition had a bold and large front-page banner headline: "Gang of five Gets $26,309 in Ybor City bank Holdup." A story subtitle credited the bandits with committing a "daring daylight robbery" and with baffling the officers trying to solve the crime. The robbery was being called the "boldest in Tampa's history," especially since it was done at the busiest hour of the morning. A different source claimed the robbery was the first holdup in Tampa's history, adding a bit of confusion to the robbery's study.

Police Chief Bush and a detail of detectives got little information from the bank's employees and even less from the scores of passersby. They followed one lead and later surrounded a house on the outskirts of town, keeping it under surveillance for four hours. But the hours passed with no sign of the bandits, and Bush and his squad left. Sheriff McLeod noted more leads and optimistically predicted an arrest within twenty-four hours.

Yet another subtitle to the story was "Gant's Name Always Pops Up." The "mysterious Gant" was, according to the story, found to be involved in numerous robberies and auto thefts every time Florida officers were called to solve major crimes. Three unnamed bandits' physical descriptions were given. Robber number one was listed as five feet seven inches, between 150 and 160 pounds, aged about thirty-six and baldheaded. Number two was tall at six feet three inches and between 215 and 220 pounds with light hair and complexion. The third accomplice, said to be the getaway car driver, had a "round face, small mustache," wore a gray hat and weighed about 190 pounds.

Additionally, the sheriff's office listed an accomplice of about forty years of age, with a dark, ruddy complexion, bushy mustache and dark hair. His height was given as six feet two inches, his weight as 195 to 205 pounds and he was seen wearing a brown single-breasted suit, a soft felt hat and black gloves at the time of the heist. Interestingly he was also described as "American." A second accomplice, according to the sheriff's office, was listed at five feet eight inches or nine inches, 155 pounds and thirty-five years of age at the most. He was said to have a smooth face, fair complexion and light hair, and at the time of the crime was wearing a slate-colored suit and felt hat. Perhaps the disparate law departments were describing the same bandits with minor differences. It is also possible that combined, the five descriptions painted an accurate picture of the gang.

Gant's description at the time listed the Sumter County native as thirty-five years of age, squint-eyed, always smiling and with a small scar on his left

temple. A bullet wound on his left forearm, possibly from the Penny Farms store shootout in 1933, was added to the list. His height was listed as five feet seven inches and his weight at 160 pounds. Gant was said be of medium stout stature and partly bald, with bluish gray eyes and gold fillings between his upper front teeth. R.H. McKinney later said that he got a good look at the gang's leader. He described him as a "big, bruising sort of fellow and also the one who hoarded the door when they made me unlock the grill." Confirming the assessments made by law enforcement, McKinney said that "the leader was steady as a die. He knew what he was doing from start to finish."

On March 5, the case turned toward the east coast of Florida when an abandoned car, similar to the one used by the bandits, was found in the Vero Beach area. Local authorities found the abandoned sedan approximately five hours after the holdup, stripped of its license tag and any clues or marks that identified the vehicle. Information emerged that the abandoned vehicle had been stolen in Sarasota nearly one week before the bank heist.

Five days after the robbery two rewards were posted for information leading to the arrest of the bank robbers. Hoping to spur the search the Florida Bankers Association posted a $1,000 reward for general information leading to the arrest of the perpetrators of the crime. The feds announced that the usual $200 reward for information leading to the arrest of post office burglaries would be applied toward the capture of Gant. Simultaneously, Sheriff McLeod and Chief Bush offered $1,000 for arrests. The point had now been reached when Hugh Gant was dubbed "Florida's Public Enemy #1." The reward, according to one source, stipulated that Gant's portion was either *dead or alive*. It was said that Gant had been positively identified for the crime and that he was wanted as the leader of the gang that had been "knocking off" small banks throughout the state for several years. They confirmed that warrants were out for Gant for bank robberies in Mulberry, Bowling Green and St. Cloud, and added Branford, Apopka and Cross City to the tally, as well as Reddick and Cottondale for post office robberies.

As is the case with reputation, Hunt and Gant were credited with numerous crimes that may not have been theirs at all. Other active criminals received similar treatment. One such crime was the bank robbery in St. Cloud, Florida, that occurred on March 22, 1934. It was the FBI who credited Hunt and Gant with this job.

The *Orlando Sentinel* initially raised the area's level of hysteria to national levels with the title "Dillinger Named St. Cloud robber." The March 22, 1934 story suggested that nine witnesses identified the "notorious escaped bank bandit John Dillinger" as one of the three robbers of Citizens Bank in St. Cloud. Dillinger had escaped the Crown Point facility in Indiana

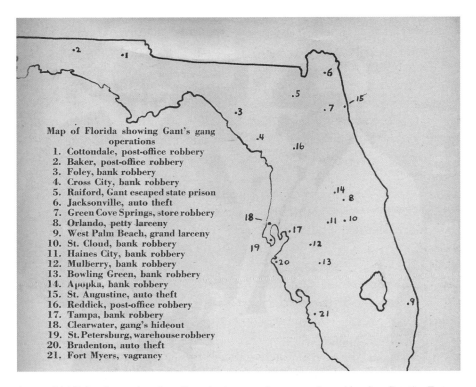

Map of Florida showing Gant's gang operations
1. Cottondale, post-office robbery
2. Baker, post-office robbery
3. Foley, bank robbery
4. Cross City, bank robbery
5. Raiford, Gant escaped state prison
6. Jacksonville, auto theft
7. Green Cove Springs, store robbery
8. Orlando, petty larceny
9. West Palm Beach, grand larceny
10. St. Cloud, bank robbery
11. Haines City, bank robbery
12. Mulberry, bank robbery
13. Bowling Green, bank robbery
14. Apopka, bank robbery
15. St. Augustine, auto theft
16. Reddick, post-office robbery
17. Tampa, bank robbery
18. Clearwater, gang's hideout
19. St. Petersburg, warehouse robbery
20. Bradenton, auto theft
21. Fort Myers, vagrancy

A map highlighted actual and attributed crimes to the consortium. (*American Detective Fact Cases*, April 1938)

on March 3 and initiated a nationwide manhunt. This was the infamous "carved wood gun" escape. From there he and his outfit went on a spree that, if true, was harried and frantic. On March 6, Dillinger participated in a bank heist in South Dakota. One week later they struck again at a bank in Iowa. One day later they made for Minnesota to get medical attention for an injured gang member. A brief hiatus followed until Dillinger and his crew shot it out with law enforcement in Minnesota.

Two of the nine St. Cloud witnesses were bank employees and three bank patrons, all of whom were forced to lie on the floor during the heist. It is probable that a combination of hysteria and fright led them to identify Dillinger. P.W. Green, area road construction foreman, had given particular attention to a car that had been driving by the bank every day for the previous week. The bold heist, resulting in a $10,000 haul, occurred in daylight with the three escaping in a blue Plymouth coach allegedly bearing Florida plate number 67265 *and* Indiana license number 372458. Coincidentally, the Indiana plate was stolen from a Ford sedan belonging to a woman from Marion, Indiana, near Dillinger's hometown of Mooresville. If the Indiana

plate was seen, it certainly muddies debunking his involvement through coincidence and proximity.

Photographs of Dillinger and a number of other criminals were taken to St. Cloud by Goree Carruthers, Orange County fingerprint expert. In all cases except one, the picture selected was that of Dillinger. Those identifying the photograph were allegedly unaware that it was the famed bank robber. Hunt and Dillinger did bear a resemblance. Bank cashier Paul Kirkpatrick, who was forced to open the vault and carry the loot out to the waiting vehicle, was emphatic in his selection of the picture of Dillinger. He was in proximity to the robbers when they scooped up an additional $800 in currency and coins from behind the cage. They even insisted on taking all the silver coins and pennies, which were placed in a bag while the bills were shoved into a pillowcase. Taking such heavy baggage as coins would have seemed to impede the robber's progress. However, the criminals delegated the task to Kirkpatrick, who was forced to heft the bags of coins over his shoulder and take them out to the waiting car, after which he was forced to ride the car's running board for one block.

During the ride Kirkpatrick noticed a machine gun on the back seat of the coach, which authorities later suggested *could* have been the same gun taken from Lillian Howley, the overpowered sheriff from Lake County, Indiana. While hanging on for the one-block ride, the man Kirkpatrick later identified said, "Well if you want to know who is doing this, tell them it's John Dillinger." With the vehicle running at ten miles per hour, Kirkpatrick was forced to jump off. The car simultaneously careened, nearly striking three onlookers.

A woman identified as Miss Lee explained afterward that when she entered the bank during the crime she realized what was happening and went into hysterics. She was told to be quiet by one of the gang members or he would, "shoot [her] full of holes." Another witness, Mrs. Mary Green, stated that she had seen a Plymouth with an Indiana license plate traveling to St. Cloud from Narcoossee each day the past week. She said that the car returned the same way about one hour later and stopped at the end of a dragline. The day before the bank heist, however, the car did not stop at the end of the dragline. Instead, it returned about 3:00 p.m. at a high rate of speed and nearly collided with the dragline, plowing ahead in the direction of Narcoossee. Presumably the perpetrators were making their last dry run.

Eventually over thirty witnesses selected the Dillinger photograph. One St. Cloud man who watched the trio leave the bank identified a photograph of John Hamilton, a Dillinger accomplice, while Orange County officers received word from Fort Lauderdale police of unconfirmed reports placing Dillinger in the area. Gant bore a general resemblance to Hamilton.

Graduation to Bank Thefts

Dillinger historians have traced many of his wanderings. It is accepted that he and his girlfriend Evelyn "Billie" Frechette drove to Daytona Beach, Florida, with four others in mid-December 1933. On December 21, 1933, accomplices Homer Van Meter and Charles Makley joined the gang, giving credence to a vague familiarity with the area. On New Year's Day, 1934, the gang fired their machine guns at the moon while on the beach. Two weeks later Dillinger and his crew hit the First National Bank in East Chicago, Indiana. Next, they struck the First National Bank of Mason City, Iowa on March 13. It seems especially unlikely that Dillinger and his gang would have been so active in the Midwest only to return to Florida to hit one bank in St. Cloud, Florida.

Exactly four months after receiving the public enemy designation, Dillinger was gunned down outside the Biograph Movie Theater in Chicago, Illinois. Dillinger's involvement with the St. Cloud bank job is probably as unlikely as many other crimes attributed to him throughout the country. A handful of other significant gangsters received equal treatment. For example, Alvin Karpis saw a newspaper with the title "Karpis robs Bank in Michigan." At the time he and the FBI's J. Edgar Hoover had just disembarked from an airplane ride to St. Paul, Minnesota, to refuel and eat. Karpis is supposed to have laughed and noted that he had a perfect alibi.

The trio of Gant, Hunt and Elbert Croft was more likely responsible for the St. Cloud robbery than Dillinger and his crew. Sheriff Tindall got a break when Frank Price, president of a nearby Dade City bank, notified Tindall that an unusual influx of silver was flowing into his bank. He added that several "free spenders" were noticed in town but verifiable documentation shows that Dillinger and his gang were far to the north, thereby dismissing the Dillinger presence. Descriptions by Kirkpatrick and Price were compared and Elbert Croft was positively identified as one of the robbers. For his effort Croft received a twenty-year sentence for armed robbery and an additional five for the theft of Roy Prentis's car, with which he later made an escape attempt from the Osceola County Jail.

The vehicle used during the St. Cloud heist turned out to have been one stolen on March 15 from Dr. H.A. Hensley of Haines City. Despite police searches for the coach throughout central Florida, no trace was revealed. A report had the vehicle heading toward Seminole swamplands and toward Winter Park. Citizen's State Bank, which was chartered in 1926, did not become FDIC insured until August 23, 1935, leaving the crime a state rather than federal matter.

Another heist, one that occurred in Apopka, Florida, was inexplicably foisted on Hunt and Gant. In his book *History of Apopka and Northwest Orange County*, Jerrell Shefner cited an *Orlando Sentinel* article dated December 23,

1926, which offered proof that the FBI erroneously tagged the pair with the Apopka heist, though it did not give a date for the robbery. Two robberies occurred in Apopka during the period when Hunt and Gant were active. The first, however, happened while their automobile theft and fencing operation was just emerging from its infancy.

According to Shefner, a night-shift switchboard operator became a local hero when two men attempted to rob the Apopka State Bank in 1926. Hearing an alarm, Frank Walters called the police and notified a cashier named Talton of the proceedings. Talton, in turn, was able to get to the bank in time to foil the robbery. The FBI may have intended to place the 1934 rather than 1926 Apopka robbery on Hunt and Gant. However, it was the Lonnie Parrish Gang that struck the Apopka State Bank in 1934 after improvements of the bank made it "so attractive." They escaped with $4,000. Cashier F.L. Burgust and Mrs. Grace Van Sickley were taken as hostages. Van Sickley was released after the robbers secured their ride but Burgust was forced to ride the running board. The outlaws were apprehended by Harry Hand a few days later. Therefore, it seems probable that Hunt and Gant can be exonerated posthumously from both of the Apopka heists.

An FBI summary, dated June 9, 1938, suggested that Hunt and Gant were involved in five additional crimes, though they had no fingerprint corroboration. Gant was wanted for a safe burglary in Sparr, Florida, that occurred on October 16, 1933, and for a similar crime in Atlanta, Georgia, on September 6, 1934. He was also alleged to have perpetrated a bank robbery in Wauchula, Florida, on May 27, 1935. It is possible that Gant was involved in the Sparr safecracking, though it would have occurred only shortly after the Baker Post Office break-in and two weeks after his jailbreak in Alabama.

Additionally, the pair was sought for a safe burglary in Lakeland, Florida, though the feds did not provide a date for the crime. Federal investigators also had interest in Hunt and Gant for a safe burglary that took place in Miami, Florida. The target was the Seaboard Air Line Railroad. Dates for the job included August 8, 1933, or August 7, 1936. The fact that two dates were given suggests two separate, most likely unrelated crimes and weakens the feds' assessment that Hunt and Gant were involved. No evidence has emerged suggesting that the two ever committed a safe burglary; however, post office robberies may have been credited properly to them.

In terms of crime, Hunt and Gant were to Florida what Dillinger, Karpis and others were to the Midwest. Gant was said to have "undoubtedly the longest criminal record of any native-born Floridian in history" at the time. The Federal Bureau of Investigation, in a bulletin issued days before the

POST OFFICE DEPARTMENT
OFFICE OF INSPECTOR IN CHARGE
ATLANTA, GEORGIA

Case No. 51757-D.
(Baker, Fla.)

REWARD!

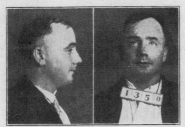

(SEE FINGERPRINTS ON THE REVERSE SIDE)

FINGERPRINT CLASSIFICATION

| 14 | 31 | W | 11 | 11 |
| 27 | | W | 01 | 12 |

White; age, 33; height, 5 feet 6 3-4 inches; weight, 158 pounds; build, medium; complexion, light; hair, black; eyes, blue; teeth, bad; small scar left temple; occupation, farmer; born, Webster, Fla.; former home, Tampa, Fla.

Gant was last seen at Crofton, Ky., August 17, 1934, where, with wife, he operated filling station and sandwich shop as A. L. Jackson. He left Crofton night of August 17 in a 1934 Chevrolet standard coach, maroon color, serial No. 8DC02-1001, motor No. M43019, Christian County, Kentucky, license No. 148423. He also has Florida license No. 172941.

HUGH GANT
ALIASES:
A. L. JACKSON, CHARLES HUGH SMITH,
LLOYD E. SPARKMAN.

Under indictment Northern District of Florida, burglary of post office at Baker, Fla., September 5, 1933; implicated with others in burglary of post offices at Floral City, Tampashores, and Sparr, Fla.; escaped from State Prison Farm, Raiford, Fla., April 24, 1933; under indictment for bank robbery Cedar Keys, Fla., February 7, 1934, and believed implicated in robbery of banks at Orange City, Fla., October 1933, and St. Cloud, Fla., March 21, 1934; also, under indictment at Mobile, Ala., for violation of National Motor Vehicle Theft Act.

A reward not to exceed $200 may be paid for the arrest and conviction of any person breaking into a post office with intent to commit larceny or other depredation.

If apprehended, or information of importance is secured, wire the undersigned, Government rate collect; or telephone.

J. W. COLE,
Post Office Inspector in Charge,
Atlanta, Georgia.
(Telephone Main 3517, Ext. 97).

AUGUST 27, 1934
Saint Louis Post Office — 8-27-34—5000

The post office inspector was one of many who offered a reward for the capture of Gant and Hunt.

Columbia Bank heist, listed him as being connected with a dozen Florida crimes. They added that the Federal Grand Jury at Mobile, Alabama, had indicted Gant on interstate transportation of stolen automobiles from Lakeland, Florida, to Mobile, Alabama, and accounted for his stays in jail.

The Federal Identification Order, more commonly known as a "wanted poster," described Gant as thirty-five years of age and added that his "peculiarities," described in the blunt language of the day, were his squint eyes and his incessant smile. The order listed his surviving relatives. His father, John R. Gant, was living in Floral City while three sisters were in Texas. Mrs. A.D. Hunt was living in Houston. Gant's "paramour," Audria Lee Cotton, was alleged to be living in Auburndale, Florida. Cotton, also recorded in official and unofficial records as Audie Lee Cotton, married Gant in 1934. Gant, however, married under the alias Charles Hugh

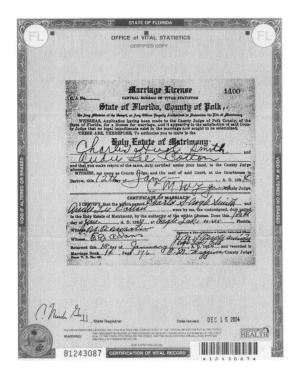

Using one of his many aliases, Gant found time to marry Audie Lee Cotton in 1934.

Smith. The certificate of marriage was dated January 12, 1934, at Eagle Lake, Florida, in Polk County. Their marriage license, dated the same, was recorded and issued at Bartow.

An Audrey L. Cotton was born November 13, 1915. The 1930 census, taken in Auburndale, Florida, listed her father as Drew and her mother as Cora, ages thirty-nine and thirty-six respectively. Both were Alabama natives, as were at least the first four children. They married early, at ages nineteen and sixteen, and by the 1930 census had seven children. Audrey was the fourth born and would have been approximately seventeen years old when she married Gant.

The Cottons rented a place in town and found work in the citrus industry. Drew worked as a canner while Cora worked in the packinghouse. Audria later obtained a divorce from Gant on January 20, 1940, according to FBI records in Houston, Texas. Gant and Cotton had a nine-month-old, according to a June 9, 1938 FBI memorandum. The child's name was obliterated on the document and may have been a Smith, Gant or Cotton. She later remarried to a man named Romero lending the possibility of a fourth surname for the child.

Only twelve aliases were listed on the wanted poster, but the record included details from the first Tampa auto theft in 1927 through arrests

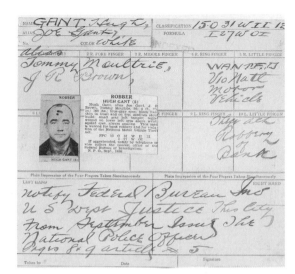

A card that indexed and classified criminals, in this case listing Gant as a robber.

in West Palm Beach, Gant's first stay at Raiford, the arrest in Mobile, Alabama, and another in DeLand, Florida. His arrest in Geneva, Alabama, and his second stay at Raiford followed. At the time, Gant was wanted by the U.S. Post Office Department for the Baker break-in and by the United States Department of Justice for violating the National Motor Vehicle Act.

Whether because of the rewards or for public safety, a person emerged with information that provided a lead in the Ybor City robbery. A filling station employee, L.M. Kendall, said that he had seen a group of three men just before they stole a blue Ford sedan from a Sarasota automobile agency. Kendall went to Tampa with Sheriff C.B. Pearson of Sarasota County to look through photographs in police files. He made an identification but who he fingered is not known. Shortly thereafter, an anonymous note was received by Sarasota Chief Deputy E.A. Garner that mentioned the blue sedan.

Federal officials continued to add information into Gant's history. His prison breaks, one kidnapping and a suspected arson charge were added to his cache of crimes. In addition, his list of aliases grew from twelve to nineteen. The suspected arson case related back to the November 15, 1931 auto theft of J. Hartwell Jones's car, which was parked near the First Christian Church. On that evening Tampa police officers staked out a house at Plymouth and Mitchell Streets that someone had recently attempted to set on fire. In the middle of the night, two men drove into a garage at the residence and left a car. The car was possibly the same one stolen from Jones.

After daybreak the men returned for the vehicle and were confronted by the police. A shootout occurred and one man, claiming to be Bill Bonner, was captured. The second suspect evaded capture. Three months later

Gant was charged with participation in the theft. How police linked Gant, whose involvement with the auto robbery was chronicled, to the fire remains unknown.

An interesting sidelight of the Columbia Bank robbery involved Chief of Police Bush. Only nine days after the Ybor City robbery the *Tampa Morning Tribune* published an article titled "Aldermen Try to Stop Pay of Chief Bush." The comptroller was instructed not to issue the chief's salary. The mayor was leading an apparent power play to block Bush as the acting police chief. Bush was unavailable for comment since he was in pursuit of the bank robbers. The Board of Aldermen ordered an investigation of expenses during the search for the men who robbed the Jefferson Loan Society in a stunning $125,000 diamond heist. That crime occurred on January 4, 1935, and was not credited to Hunt and Gant.

A much more intriguing and revealing sidelight was a card written by H.D. Hunt, Alva and Truby Hunt's father, which was published in the *Sumter County Times* on April 10, 1936. Truby Hunt had been taken to Tampa in connection with the Ybor City heist. H.D. asked area citizens to withhold judgment since he was convinced that Truby was innocent. In fact, H.D. offered an alibi. No information has been uncovered suggesting that Truby was involved.

Six days before H.D. Hunt penned his letter to the *Times*, Alva Hunt and Hugh Gant were at it again when they stole a vehicle in Bainbridge, Georgia. It was the vehicle they would use for their June 2, 1936 heist of the Farmers and Merchants Bank in Foley, Alabama. That bank job netted them $7,000 and turned out to be their last bank robbery.

Between the Foley job and their last crime, an automobile theft that was possibly part of a planned but never realized bank job, Alva Hunt and his paramour Alene Bledsoe found time to marry. They went to Bay St. Louis, Mississippi, and exchanged vows on January 7, 1937, according to the FBI. Records show an Aileen Bledsoe was born on either April 6 or September 30, 1918. Her hometown was Malvern, Arkansas, which is located in Hot Spring County. Bledsoe was the daughter of William and Pearl and the last of three children.

Presumably happily married, Hunt along with Gant targeted and succeeded in an automobile theft on October 28, 1937, in Pensacola, Florida—their last known crime. The heat was on the gangster pair who utilized hideouts and connections from Florida to Texas between October 1937 and January 1938 and sensing the presence of law enforcement, traveled undercover. On January 11, 1938, the pair was apprehended in Houston, Texas. A day later their Jackson, Mississippi hideout, flush with an arsenal of weapons, was raided. From there the dominoes that made up their lives began to tumble.

Notoriety in Print

Hunt and Gant's notoriety grew so that, shortly following their capture, they made it into magazine print. *American Detective Fact Cases*, dated April 1938, boasted a cover like most of the "true crime" editions of the time. It showcased a brunette, draped within a mink coat, applying blood-red lipstick. In the mirrored reflection of her makeup compact is the stern profile of a mad-dog criminal pointing a revolver in her direction. Like the other magazines of the period, *American Detective* was loaded with current and evocative stories, all for only a quarter.

Four stories were highlighted on the cover, including "Texas The Heat Is On!" which covered the capture of Hunt and Gant. L.L. Mayers wrote the eight-page story that featured Lieutenant Tom Eubanks of Houston, Texas. A creative layout starts the story with a playbill-style cover sheet and a crudely rendered map of Florida, with numbers showing operations of the "Gant Gang." Details from the story provide important and interesting insights into the pair's antics and personalities, while focusing more on Gant. Act I, according to the playbill, took place in Tampa on May 9, 1929, and on November 16, 1931.

Gant was being interrogated by Tampa police and Chief W.D. Bush for suspicion of automobile theft. According to the author, Gant sat nervously while Detective D.D. Stephens processed paperwork. Stephens finally told Gant that they did not have enough evidence and Gant immediately relaxed and adopted a cocky attitude. Allegedly he rose to his feet and swaggered away, trying to make his stature greater than the five feet seven inches he actually possessed. In the slang language of the day he was purported to have said, "Okay, copper…I can scram, then?" But before he could scram, Lieutenant Eubanks asked to speak with him briefly. Eubanks told Gant that

American Detective published the story, "Texas the Heat is On!" It focused more on Gant's character and the Penny Farms event. (*American Detective Fact Cases*, April 1938)

though they had no concrete evidence they knew he had "swiped that car." The officer attempted to set Gant straight, suggesting that he was not cut out to be a bad man. Gant interrupted, telling Eubanks to "can the sermon," waved goodbye and left. Eubanks assessed Gant as having a personality of persecution, feeling that society was out to get him. What stood out to the officer were Gant's coldness and his lack of courage. He concluded that Gant could drive a car fast and well and could love women, but was "yellow." Much of the article is designed to bolster the latter assessment.

For some reason Eubanks "decided to keep an eye on him." A couple years passed during which Gant was involved in arrests, indictments, auto thefts and other incidents. Then on November 16, 1931, an incident related to the mysterious arson charges occurred in Tampa. Policeman Jim Linville had been assigned to stake out a house located at 213 Plymouth Avenue. The evening before, a "pyromaniac" had attempted to burn the house in a possible insurance scam. It had been prevented but appeared to be suspicious enough to necessitate the stakeout.

It was past midnight when automobile headlights cut on at the house across the street from where Linville was positioned, changing his opinion

A playbill-like outline shows the main cast of characters and highlights Riley Gant in his final act. (*American Detective Fact Cases*, April 1938)

that the place had seemed unoccupied. Silhouetted in the car's lights was a man preparing to open a garage door. Linville recognized that it was Gant. The officer assumed that either Gant was involved with the arson attempt or he was returning a stolen car to the house for safekeeping. Linville trekked along an alley to reach a drugstore to call his headquarters. Stephens answered and agreed to quickly join Linville.

By the time Linville and Stephens reconnoitered in a hiding spot, they saw that the perpetrators had returned for the car. They assumed Gant had backed out of the garage because another man was busy closing the garage door, and it was not Hugh Gant. Stephens whispered to Linville, "We've got a beef on that car." It was a Studebaker with a telltale dent in the front fender. The officers charged forward, and Stephens collided with the man closing the door, wrestling with as the thief fought for his freedom. The battle that ensued was, according to reports, vicious and protracted. Linville, not decisive about providing assistance to his fellow officer or tracking Gant, hesitated.

Suddenly, the car's motor roared to life and Gant spun the tires, shooting gravel from the driveway. Linville, on foot, charged after the disappearing

car firing his pistol three times. The car continued along Plymouth Avenue and "turned a corner on two wheels." Linville returned to find his partner kneeling on Gant's accomplice, Bill Bonner. Allegedly he complained about Gant running out on him, calling him a "louse." Bonner continued saying, "I mighta known that guy'd do a thing like that. It was a fair fight too; you coppers never pulled a gun until he started to duck."

Apparently as Gant ducked out, putting the car on two wheels, one of Linville's gunshots hit its mark. The stolen vehicle was found the next day in a ditch near Orlando with dozens of bloodstains inside. Gant's trail dwindled from Tampa to Orlando and faded in Brooksville, as Gant crisscrossed his way through central Florida.

Act II picked up Gant's whereabouts in Alabama. In April of 1932, Tampa Police narrowly missed picking him up, but then Gant was arrested in Mobile for running illegal booze. Under an alias, he was able to post and then forfeit bond. Then on August 18, 1932, he was arrested in Deland after having outdistanced motorcycle police near the scene of a "large cigarette robbery." The speed and prowess of his driving and the proximity to the robbery piqued the local authorities' interest. Authorities responded by staking out the residence of an "attractive brunette whom Gant had previously visited in Deland."

The stakeout proved both effective and embarrassing. Officers literally caught Gant with his pants down while his companion was in an equal state of disrobing. He was then taken back to Tampa for his participation in the theft of J. Hartwell Jones's car. At sentencing Gant supposedly "quailed before the judge" and "looked like a whipped hound as the court led him away." In addition, according to Officer Eubanks, Gant "whined that the law was always picking on him." His old accomplice Bill Bonner, having served a brief sentence for the same crime, allegedly sat in for sentencing and grinned as Gant was taken away.

It was only four months later when Gant escaped from Raiford. Details provided by the article add more to Gant's character and criminal prowess. A large delivery truck passed through the gates at Raiford. Ten minutes later sirens wailed and announced the escape. Apparently he had hidden under a tarp in the truck. Two unnamed "cronies" actually planned the escape, but Gant horned in. When the three found the truck overcrowded with boxes it was Gant who "scrambled aboard the truck" as it was pulling out of the yard. The companions attempted to follow suit and Gant allegedly kicked them off the back of the truck.

It is important to note two factors that impact the accuracy of true crime publications and, for that matter, newspapers of the period—record-keeping/communications and bias. The former have improved dramatically

since the 1938 publication courtesy of technological breakthroughs. True crime–style magazines were an excellent tool used by law enforcement and the FBI to change the appeal and romance of the criminal life and often contained a purposefully slanted perspective.

Questions of inaccuracy appear to be most prevalent regarding the Penny Farms robbery attempt and shooting of Riley Gant. According to two newspaper accounts, Riley and two others attempted the late-night robbery and were ambushed by a night watchman. The night watchman gunned down Riley as the other two members fled. He fired at them, possibly winging one of the criminals. According to the *American Detective* story, "it was high noon" in Penny Farms when the third and final act began. The town was described as an "area of thriving groves and plantations," and residents were home having lunch. The store in question had a reputation as a "flourishing institution."

A large sedan pulled in front of the store and two men got out and headed toward the sidewalk while the third sat behind the running car. As they arrived at the store entrance, each man donned a mask and drew guns. There were only two clerks and the noontime crowd was nonexistent. An observer named Ambrose Hill was resting in one of his barber chairs and noted that the man behind the wheel was a stranger. When he witnessed the men put on their masks he jumped for a phone and raised an alarm.

Penny Farms was reputed to have a well-organized and efficient group of volunteer citizen constables. The message spread from home to home and the men gathered guns. The stirring raised the getaway driver's suspicion, so he headed out of the car to warn his compatriots. As he returned toward his car he saw armed men running at him. Not sure if he could reach the car in time, the bandit remained near the store's front door and called again to his partners. As they exited, the driver hit the ground, the two masked men paused and the gunfight began.

One of the masked men was hit. He dropped his gun and fell forward as the other one crouched down for safety while firing "wildly at the vigilantes." To their credit the citizen patrol was making an organized advance toward the store, creeping carefully behind cover. Then suddenly one of the bandits made for the car, running in a zigzag pattern. He reached the car as his fallen companion called out, "Hugh," and added, "Don't leave." The third accomplice attempted to pull the wounded man to safety but realized escape was futile. Supposedly the wounded man's mask slipped, revealing the dying countenance of Riley Gant. Again he called for his brother by name and pleaded in whispered tones for him to not leave. His nearly inaudible pleadings were ignored as Hugh raised a cloud of dust and dodged a fury of bullets. Riley said, "I knew he'd yellow out." The other accomplice shook

his head and said to Riley, "A hell of a brother you got." Riley shook his head in agreement and died.

Gant, according to news accounts, had a sizable record, but the *American Detective* story suggested the opposite, offering that Penny Farms may have been his first job. The article also suggested that Tampa resident Johnny Burke was the other participant, but it was most likely Alva Hunt. True crime magazines took great liberties to spice up their copy. It is interesting to note that one of Gant's wives was Ida Burke. It is not known if they were related.

Gant disappeared again but resurfaced two months after the aborted Penny Farms robbery in Orange City, Florida. In October of 1933, the Orange City Bank was robbed of $10,000, and one of the robbers was identified when his mask slipped and supposedly revealed the famed visage of Hugh Gant. Another bank robbery took place on February 7, 1933, and Gant was pinned as one of the trio who pillaged a Cedar Keys institution. Gant was then "recognized" as part of a trio that hit a bank in Apopka, and "a few days later" in Branford, Florida. It seems unlikely and nearly impossible that he went on such a bank robbery tear, but based on the evidence of the time, the author and Officer Eubanks could make a connection between Gant and the rapid-fire bank robberies.

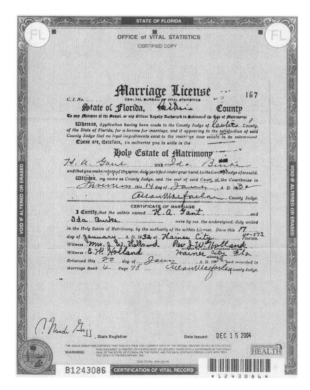

Hugh Gant married Ida Burke, who was an alleged accomplice in at least one early crime.

Supposedly, during the Branford robbery one man guarded the escape door as the other two pilfered cash drawers. An alarm shrieked and one of the bandits ceased scooping up the money and made for the door. His companion halted him saying, "It's a fire, you rat." Hugh Gant returned to rifling the cash drawers, minus the mask he had shed during his attempted exit.

Gant had created a system known to criminals as a "merry-go-round." The spokes of the merry-go-round included up to twenty hideouts where a criminal could lay low for a couple days or even a full week. Gant's relatives, paramours and accomplices were willing to house him when he was on the lam. He was able to perpetrate the string of bank jobs that followed Branford courtesy of the system of hideouts. Following the Ybor City robbery, Gant had become too hot and the merry-go-round began to unwind. Many of the spots were under surveillance. The demise of the merry-go-round system coincided with the law that made it an offense to harbor a public enemy.

In order to determine whether a hideout was safe Gant sent in accomplices ahead of him. On one such occasion, Leroy Chastain, bank robber and fugitive from the state of Georgia, was sent in and was arrested. He was returned to the chain gangs of the state. Leroy and A.B. Chastain, a farmer from Tampa who was also captured at one of the merry-go-round hideouts, each received twenty-five-year terms for their involvement in the Ybor City heist. A third unnamed suspect from Ybor City was taken at yet another hideout. All three men had no money when they were taken, and were captured preceding Gant to safety. No anonymous source stepped forward to provide money to bond them out, a typical act of loyalty amongst criminal gangs. Gant allegedly left them, feeling no loyalty for the men who were captured unknowingly testing the waters of a hideout.

During 1937 Gant was supposed to have perpetrated minor jobs such as sticking up department stores and filling stations, while teaming up with a "pal named Dewey Hunt." There is little evidence to confirm or refute their involvement with stickups, and the tagline of his pal seems to neglect a mountain of evidence that reveals Hunt's true involvement. After the death of New England gunman Al Brady in 1937, Gant was slotted in as the public enemy number one. Little of Hunt is mentioned in the *American Detective* article. An interesting photograph caption refers to Hunt as Gant's lieutenant and gun bearer. Hunt was described as having facial scars from smallpox and appeared tough but was "probably as yellow as Hugh Gant."

Christmas Eve, 1937, saw half a dozen stakeouts of Hunt's relatives in central and north Florida—cities like Tampa, St. Petersburg, Orlando and Jacksonville. The bandits were wise enough to not show up for holiday celebrations. Apparently, the FBI had been tracking Hunt's travels for a

year and was intimate with a hideout in Jackson, Mississippi. Neighbors were curious about the late-night comings and goings of "two mysterious men and the comely blonde" from the rented house. They alerted law enforcement but must have inadvertently alerted the criminals, too.

The FBI was aware that Hunt had relatives in Houston and had frequented the city. Therefore, they made the logical assumption that Hunt and Gant were headed that way. The capture of Hunt, Gant and Alene Bledsoe is chronicled in Houston newspapers. Eubanks and the story's author leave out much of the verbal jousting between the captives and captors. However, the author likens Gant to a "yellow rat" and reiterates Hoover's assessment that Gant was more dangerous than Dillinger in the way that a "snake is dangerous when hidden from its victims." It concluded braggingly with "Public Rodents No. 1 and No. 2" being held in Tallahassee for trial.

Two years later, *True Detective* magazine, dated August 1940, published a substantial story titled "Double for Trouble, the Tragic Case of Chastain— the Man Condemned by Circumstance." Jay Hoyt authored the work, which focused on the sad coincidence of Artice Boaz Chastain's similar appearance to Hugh Gant. According to Hoyt, no event in the criminal history of the Hunt-Gant combine caused more confusion or had such long-lasting impact as the Ybor City bank robbery. At the time of the heist confusion by witnesses actually impacted the police investigation.

Witnesses claimed they saw either three or four participants. Apparently two men exited a sedan, most likely light blue in color, while the getaway driver remained under the wheel. One of the robbers was dressed in dapper style, wearing a "fashionable light fedora turned rakishly down on one side and a bright red imitation strawberry ornament in the left lapel of his well-pressed suit." He turned out to be the leader, as was demonstrated by his proficiency, and a "half-smile played about his lips as he crossed the sidewalk with businesslike strides to the bank entrance." This most likely was Gant, with his companion Hunt following close behind.

Details of the Ybor City robbery corroborated newspaper stories from 1936. The robbers entered the bank, and Gant strode up to the only bank customer and jammed a pistol in his back. Gant told him to "take it easy pal" and added that it was a stickup and that he "better reach."

Hunt apparently drew a large-caliber automatic weapon, swung it around the bank's interior and told everyone to get "down flat on your bellies." He added, "I don't want any funny business." Cashier Roger M. McKinney and the three tellers, Nick Albano, Thomas J. Passaron and John Lazzaro followed the threat but Vice-president George R. Simpson did not. Whether he was obstinate or, in his sixties, failing in hearing is not known, but Hunt intensified his threat toward Simpson, at which point Simpson backed

against a wall and slid down into a sitting position on the floor, holding his hands half raised. Hunt persisted at Simpson while Gant "herded the lone customer toward the rear of the room and through a swinging gate." John H. Shea, inspector for the Burroughs Adding Machine Company, was in the back working on the bank's equipment and was told to join the customer. They were then marched behind the cashier cages and joined the tellers.

Everyone but Simpson was gathered together, facedown on the floor, under the menacing control of Gant. McKinney was then ordered to open the door to the vault. Hunt joined Gant and McKinney at the safe, pulled a flour sack from underneath his coat and began scooping out money, bonds and securities. Gant kept his eyes on the others while pouring loot into a sack. He then noticed a bundle of cash that lay partially hidden under a newspaper, a custom common to banks since the Depression-spurred robbery craze began.

After filling their sacks, Gant and Hunt left the bank, with a quick glance back at those they left behind. Both men got into the back seat of the sedan and the driver stomped on the gas. He steered hard to the right with a skid onto Twenty-first Street, got the car under control and quickly sped away.

At about the time the robbers were entering their getaway car, S.R. Housh, engineer for the Tampa Box Company, arrived at the bank. He glimpsed the license plate and was able to supply the "only real clue." Housh described the vehicle and remembered that the last two numbers were 79.

Shortly after Deputy Sheriff Henry Van Patten arrived, he drove by and mistook the large gathering outside for a Works Progress Administration payday. Someone in the gathering spotted Van Patten's vehicle and yelled that a robbery had just occurred. Van Patten ran into the bank to observe the scene and gather clues. An alert was sent out to police officers throughout the area who "raced to plug every exit from the city." Meanwhile, Van Patten began to interview those inside the bank.

McKinney was credited with providing the best descriptions of the two robbers and the most accurate details of the robbery. Shea offered a similar rendition of the events. McKinney, Shea and Housh all agreed on general descriptions of clothing and appearances. Where they differed was in their descriptions of Hunt, the less memorably dressed of the two. Simpson was apparently "so shaken" that he was unable to provide accurate information. In fact, he was even unsure of how many robbers were involved.

After Van Patten had gathered the witnesses' stories, Chief Detective W.D. Bush, a squad of assistants and Sheriff Jerry McLeod arrived at the bank. Bush determined that the robbery was professional in all aspects. The moment that the robbery occurred coincided with a time that no streetcars were in the area. Their presence could have potentially slowed the getaway

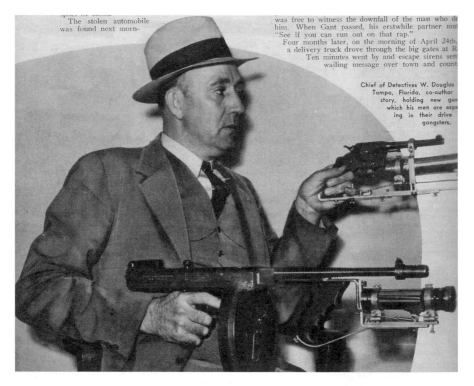

Chief of Detectives Bush, a co-author for "Texas the Heat is On!" is pictured testing new crime-fighting "iron." (*American Detective Fact Cases*, April 1938)

car's escape. He reasoned that a less-knowing group might have attempted to escape down Broadway, the most direct exit from town. Instead they chose a more circuitous route.

Bush determined from the description of a "calm, easy-going, half-smiling" perpetrator that Hugh Gant was probably the leader in question. It seemed logical to Bush and other law enforcement agents that since Gant was there, then Hunt must have been the second robber. Bush thought that two other robbers, LeRoy Chastain and James Backus, might have been involved as well. Chastain had been sentenced to serve between ten and twenty years for a previous bank robbery but had escaped from a Georgia highway work gang in November of 1935.

The chief ordered photographs of Gant, Hunt, Chastain and Backus to be hurried to the bank for the witnesses to peruse. Simpson, McKinney, Shea and the three tellers all concurred that the photograph of Gant "much resembled" the leader. Though Bush did not know the whereabouts of Gant, Hunt or Backus, he knew that Chastain had a brother living on the outskirts of Tampa. Chastain's brother, Artice Boas, was married with six

Police can be seen searching through a Tampa crowd shortly after the Columbia Bank robbery. (*American Detective Fact Cases*, April 1938)

A.B. Chastain is pictured having his fingerprints taken. Chastain served time at Raiford State Prison based on his similar appearance to Hugh Gant. He was ultimately exonerated. (*American Detective Fact Cases*, April 1938)

children and lived a modest life. He kept a one-story, unpainted wood-frame house that was balanced on concrete piers. The home sat on five acres that the Chastains had purchased three months previous to the robbery, paying $750—$45 down and payments of $10 per month.

Chief Bush and another officer drove out to State Highway 17, passing the city limits out to Six Mile Creek. They stopped at Quinn's Gasoline Station, which was situated about three blocks from the Chastain home. Bush spoke with Arthur Quinn, owner of the station and one of Sheriff McLeod's "ace deputies." Chief Bush, Deputy Quinn and Mrs. Quinn joined Al Cason and examined photographs of LeRoy Chastain. Cason was the owner of the Reliable Wrecking Company and leased a building from the Quinns. Mrs. Quinn and Al Cason told Bush that Artice, known as A.B., had been working on his driveway the whole day hauling dirt in his Model T truck. Bush told them that he was not the one that law enforcement was looking for but for his brother LeRoy. Neither Quinn nor Cason recognized the picture of the Chastain brother.

Bush believed that LeRoy would show eventually, so he kept the area under surveillance from the filling station for seven days. They noticed nothing suspicious during that time. Since it became apparent to Bush that LeRoy was not going to make contact with his brother, he decided to search the house. Bush, Chief Assistant M.C. Beasley and a cluster of detectives surrounded the home and then entered the house simultaneously.

Mrs. Chastain was there with three of her youngest children. She was pointedly asked, "Where's LeRoy?" She stated that they had not seen him for a long time and added that the last time they did, LeRoy did not even get out of his car. He gave Mrs. Chastain ten dollars for the children. That, she added, was "several weeks ago." She stated that she even told LeRoy to give himself up. When asked where A.B. was, she told the officers that he was out planting in the backyard. The police searched the house and, finding nothing incriminating, went out to find A.B.

A.B. was seated on the bank of a stream, fishing pole in hand. He was unaware of LeRoy's whereabouts and added that he and his brother had begun to drift apart since LeRoy turned to a life of crime. He corroborated that the last time he had seen LeRoy was the night he gave ten dollars to Mrs. Chastain. A.B. was taken to Tampa headquarters for further questioning. There he denied any knowledge about his brother's current location and where LeRoy had hidden his money and guns. A.B. was placed in a cell from which he was taken periodically for further questioning. The questioning continued for days, until the FBI and Jacksonville Police captured LeRoy, at which point he was taken to Tampa and placed in a lineup along with A.B., a brother named Otto and a local suspect named W.R. Feen who had been

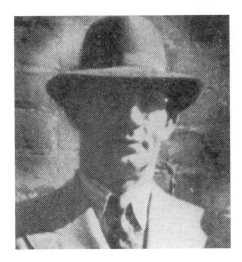

Left: Chief Deputy Quinn was one of many convinced of A.B. Chastain's innocence. (*True Detective Mysteries*, August 1940)

Right: Mrs. Quinn claimed to have seen Chastain working on his driveway while the robbery took place. (*True Detective Mysteries*, August 1940)

arrested in Jacksonville. Simpson, McKinney, Shea and the others looked over the lineup. According to a *Tampa Morning Tribune* story, the next day no one was able to identify a robbery participant from the lineup.

LeRoy was turned over to authorities in Sarasota for his involvement in a Venice, Florida grocery store robbery, while A.B., Otto and W.R. Feen were held over for further questioning regarding the Ybor City robbery and other area crimes. M.C. Beasley was convinced that none of the others "had anything to do with the bank robbery."

On March 21, James Backus was arrested in Brooksville, Florida, and another suspect, H.F. Wesley, was arrested for his possible involvement. It was eventually ascertained that Otto, W.R. Feen and H.F. Wesley were uninvolved, and they were freed. Backus, however, pled guilty to his part in the robbery of the Atlantic and Pacific Tea Company store of Venice, Florida, which took place the day following the Ybor City robbery.

Gant and Hunt remained free on the lam, while others were either convicted, in the case of Backus and LeRoy Chastain, or freed without suspicion. A.B., however, was photographed and fingerprinted and treated like a man guilty of the bank robbery. Unfortunately for A.B., as was the procedure of the day, his photograph was taken in profile and bore a tremendous resemblance to Hugh Gant. But the coincidence did not stop with a general resemblance. Chastain was then thirty-eight years old, while

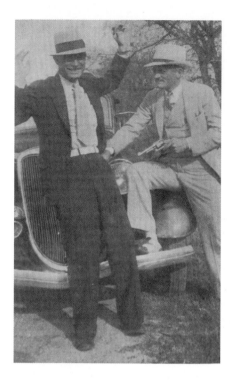

LeRoy Chastain and James Backus pretend a holdup for the camera. LeRoy's relationship to A.B. lent credence to those who wanted A.B. to serve time for the robbery. (*True Detective Mysteries*, August 1940)

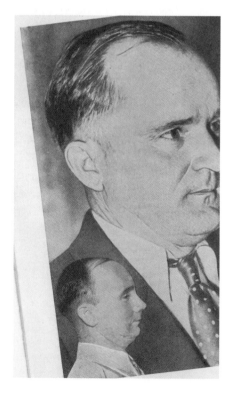

Gant, *inset*, and Chastain displayed similar physical characteristics beyond facial appearance. (*True Detective Mysteries*, August 1940)

Gant was thirty-six, and both were approximately five feet seven inches and nearly identical in weight. A significant difference was in eye color, but "what holdup victim has ever been able to be sure of the color of the eyes that sighted down a gun barrel at him?"

A.B. was held in jail for ten days and was placed in another lineup, at which time both McKinney and Simpson confidently stated that he was the leader of the robbery. The other witnesses were not so sure, while Shea was positive that Chastain was *not* the man. Officers conducted a background investigation on A.B. Chastain and found that he had never been arrested. The FBI likewise considered A.B. a nonparticipant and people from A.B.'s neighborhood were convinced that he had been at his home all morning on the day of the robbery. Despite his modest life and clean record, the positive identifications by Simpson and McKinney resulted in bank robbery charges for A.B.

Tampa was, at the time, gaining a reputation as a rough and ready city with shootings and illegal gambling. Feeling the brunt of the pressure to clean up Tampa was County Solicitor C.J. Hardee. In fact, the Hillsborough County Grand Jury recommended to Governor David Scholtz that Hardee be removed from his office for "neglect of duty in office." Setting out to sate the citizenry's desire for justice Hardee quickly brought about A.B. Chastain's indictment. He was held under $10,000 bond, and as a result of not being able to make bond, placed in the county's jail and awarded an attorney for his defense.

The day of the trial arrived and his lawyer became ill and did not appear. Hugh L. McArthur, "prominent Tampa attorney," was then appointed to handle Chastain's defense. Hardee challenged that Chastain already had legal counsel courtesy of the state and, therefore, stated that the trial should commence. Judge Moore concurred and asked, "Is the State ready to proceed, or not?" Hardee was ready.

The trial lasted three days, during which A.B. was positively identified by McKinney and Simpson as the leader of the robbery, while seventeen defense witnesses said he was not involved, many of whom remembered him working on his driveway the day of the heist. This long list of witnesses provided evidence that countered Simpson and McKinney. Among those who were convinced that A.B. was working on his driveway was Deputy Sheriff Quinn, who recalled Chastain "wearing old clothing, at his home fifteen minutes after the bank robbery took place." Quinn offered that it would have been impossible for Chastain to make it home from the Ybor City bank and change into work clothes in that length of time. In addition, Quinn recalled that Chastain was unshaven while those who perpetrated the robbery were cleanshaven.

Al Cason recalled him hauling dirt and saw him buy some gas for his Model T. Rosa Jones, who ran a grocery store a couple blocks from the Chastain homestead remembered him working there as well, and added that A.B. and his wife stopped in to buy groceries after lunch. Amazingly, another neighbor, Harvey H. Day, said that he saw A.B. "fifteen minutes before" the robbery occurred. Adding to what already appeared to be enough evidence for exoneration, Deputy Sheriff Van Patten's typewritten statement read that shortly after he arrived at the bank, "Mr. Simpson was so confused that he didn't know how many robbers there were."

Mrs. Chastain and her oldest daughter, Iris, testified that A.B. had been home all day and A.B. himself took the stand and provided the same story. Chastain's attorney summed up the testimony and asked pointed questions of the jury: "How could this man be at his home and several miles away robbing a bank at the same time?" and "How can you reason that a man who is supposed to have obtained at least part of $26,000 could let his wife and family starve after proving himself a fine father and husband for more than twenty years?" Conversely, County Solicitor Hardee's closing focused on the defendant's "close relationship to LeRoy," who was known as a bank robber. In fact, during the trial Hardee asked the jury on numerous occasions if they knew "this man's brother, the highway robber?" The jury deliberated for five hours before reaching a decision. Everyone gathered to hear the foreman state, "We find A.B. Chastain guilty as charged." Chastain received twenty-five years.

S.R. Housh, the engineer who arrived at the bank as Hunt and Gant were getting into the getaway car, was never called to testify at the trial because officials did not record his address, and he only learned about the conviction through the newspaper. He was convinced that A.B. was not the man at the bank and let officials know it.

Chastain's attorney, McArthur, filed an appeal to the State Supreme Court that dragged on for nearly one year, during which time Chastain remained behind bars in the Hillsborough County Jail unable to make bond. The Chastain family had to resort to charity and was forced to sell their home.

Unknown to most everyone involved, Sheriff McLeod, who thought Chastain innocent, set up a test for Simpson. He sent a deputy named Newton Wilson with A.B. Chastain to the Columbia Bank in Ybor City. Wilson was to remain in the car while A.B. went in to the bank to apply for a loan of $100. Chastain dealt directly with Simpson and was told that if he could get a couple of cosigners then he would be approved for the loan. Chastain left the bank and Deputy Wilson went in and spoke with Simpson

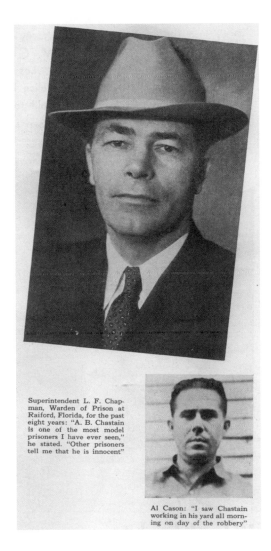

Superintendent L. F. Chapman, Warden of Prison at Raiford, Florida, for the past eight years: "A. B. Chastain is one of the most model prisoners I have ever seen," he stated. "Other prisoners tell me that he is innocent"

An eyewitness and the warden of Raiford State Prison both supported A.B.'s innocence. (*True Detective Mysteries*, August 1940)

Al Cason: "I saw Chastain working in his yard all morning on day of the robbery"

and inquired if he had seen Chastain recently. Simpson claimed that he had not, and upon further questioning from the deputy stated that he could not have been mistaken regarding his testimony.

In the meantime, Mrs. Chastain turned to the well-regarded, local religious figure Reverend J. Earl Lewis. Lewis was known for having taken in nearly two hundred wayward youths who ran afoul of the law. Under his charge, only six of the ex-convicts allegedly returned to lives of crime. The reverend believed Mrs. Chastain's story and went to the defense of A.B.

After nearly a full year had gone by, the second trial began. A new judge heard the case and Hardee's elected replacement, Joseph E. Williams, represented the county. As was the case in the first trial, Simpson and

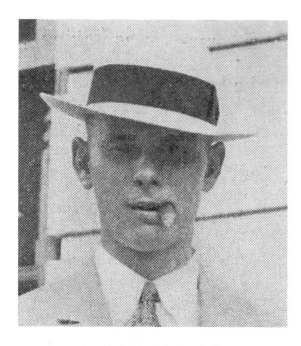

Sheriff McLeod was another law enforcement agent who was convinced that Gant's look-alike was guilty of nothing more than a similar appearance and having a bank robber for a brother. (*True Detective Mysteries*, August 1940)

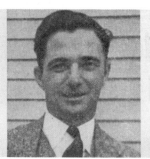

Even some of those who were in the bank agreed that A.B. was not involved in the heist. (*True Detective Mysteries*, August 1940)

McKinney confirmed that A.B. Chastain was the nattily clad bank bandit in charge of the robbery. However, this time McKinney was not completely convinced saying, "I could be mistaken." Everyone else from the first trial, including S.R. Housh, stated that Chastain was *not* the man.

Despite the overwhelming ratio of witnesses, seventeen who said A.B. was not the man to two who said he was, Chastain was again found guilty. When the verdict was read, Judge John R. Himes "registered amazement" but acknowledged his duty to the office. In that regard he gave Chastain the minimum sentence of twenty years. Chastain's attorney filed an appeal to

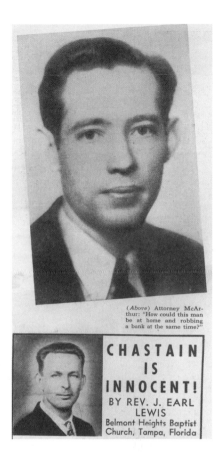

(Above) Attorney McArthur: "How could this man be at home and robbing a bank at the same time?"

CHASTAIN IS INNOCENT!
BY REV. J. EARL LEWIS
Belmont Heights Baptist Church, Tampa, Florida

Well-known reformer Reverend J. Earl Lewis fought to correct the injustice that was A.B. Chastain's sentence. (*True Detective Mysteries*, August 1940)

the Supreme Court, and meanwhile, a group of citizens were able to raise the bond money and Chastain was finally released, pending the appeal.

While Chastain and his family underwent what appeared to be an injustice, Hunt and Gant "roamed the highways and byways of the South" perpetrating various crimes that allegedly included blasting "safes in small town railroad stations, stores, and automobile agencies." They remained a step ahead of the FBI until their capture in Houston, Texas, in 1938.

Chastain, on the other hand, was innocently serving time for Gant's crime. After two years fighting for his freedom, the justices of the Supreme Court of Florida did not exonerate him. The vote was three to two. The two dissenting voters found that the evidence left "such serious doubt as to the man's guilt that the conviction should be set aside." Nevertheless, Chastain was taken to Raiford to serve his term.

True Detective author Jay Hoyt interviewed Chastain and his wife at Raiford in preparation for his August 1940 article. A.B. admitted feeling like he was living a "horrible nightmare" and feeling that he "seemed doomed." Still,

despite the struggle his wife and small children were going through, A.B. held onto the "few rays of hope" that he could. After his interview with the Chastains, Hoyt spoke with prison Warden L.F. Chapman, who "described Chastain as his most model prisoner." Chapman referred to Chastain as "an inside trusty" and said he was at the time working in the large prison kitchen. He claimed other prisoners had told him that Chastain was "doing what they call a bum rap."

Hoyt then interviewed prisoners who had been in contact with Hunt and Gant after their capture and stay in the Atlanta Penitentiary. According to Hoyt, the prisoners asked Gant "who that guy A.B. Chastain was who's doin' the rap for the Columbia Bank job." Gant supposedly said that he had not heard of A.B. Later Hoyt states that Hunt and Gant "say Chastain positively was not in the holdup." Yet Hoyt goes on to say that Gant and Hunt "disclaimed any knowledge" of the heist in Ybor City.

In total, Chastain served one year and three and a half months at Raiford as prisoner number 32515. His sentence was finally terminated via a conditional pardon, and A.B. was released on July 7, 1940. Chastain was handed ten dollars and given a gray dress suit upon his departure. A *Tampa Tribune* article dated July 8, 1940, touted Chastain's mission upon his release to clear his name. The release was timely since just days before, Mrs. Chastain had lost her job with the WPA. She and other family members held a welcome-home event for A.B.

A.B. hoped to regain employment as a painter, a job he had held since 1936, and was not overwhelmed by the notion of providing for the family. He stated, "No hard luck can faze me any more." A.B. hoped at some time to meet with Gant and Hunt in hopes of clearing his name. He stated that the FBI allegedly asked Gant about him. Gant did not claim any participation in the robbery but also claimed that Chastain was not involved.

During the time between Chastain's appeals A.B. and Tom Nobles, related through marriage, were arrested in Atlanta, Georgia. Nobles had impersonated an investigator for the governor's office and sprung Chastain from Sheriff McLeod. Nobles and Chastain traveled to Atlanta to try and coax a confession from Hunt, but the meeting was never realized. They even discussed the possibility of going to Alcatraz to speak with Gant. Chastain was sent straight to Raiford and Nobles was freed without charges for the exploit.

Chastain's brother, LeRoy, served just over seventeen years of a thirty-year term and was not released until May of 1953, while James Backus served seven years. A.B. Chastain faded from the story, a free man.

Capture

An unnamed "chief G-man" had gathered evidence that Hunt and Gant "ran riot" through Florida, Alabama, Louisiana, Mississippi and Texas during the few months before their capture. For two months, they were in and out of Houston several times, commuting between Jackson, Mississippi, and their Texas hideout. Hunt's first wife, Gant's sister Katherine, had initiated and secured a divorce and had been a Houstonian for some time, although she had since remarried and moved away. Still, they had connections within the city. Whether it was Gant's sister, another accomplice or a combination of friends and family, with the nationwide resources of the federal government after them, Gant and Hunt needed assistance.

The FBI in Birmingham, Alabama, sent out a letter, dated October 2, 1937, to all law enforcement officers in the state regarding fugitive number 1358, Hugh Gant with aliases, and fugitive number 1399, Alva Dewey Hunt likewise with aliases. Highlighted crimes included the Dixie County State Bank robbery, plural violations of the National Motor Vehicle Theft Act, harboring charges and unlawful flight to avoid prosecution.

The letter stated, "Recent info has been received that Gant and Hunt are driving a Chevrolet or Oldsmobile sedan, sea green in color, bearing 1937 Tennessee license plate number 52-973." The letter also noted that the plates used were stolen and that they were possibly accompanied by three other unknown men. In addition, the letter stressed that the information was considered *highly confidential* since it was known that the pair had good connections in Alabama and elsewhere through whom they might obtain some information "as to the issuance of this bulletin." They requested that this information not be broadcast since Hunt and Gant had been known to equip their automobiles with police radios. The heat was on and Hunt and

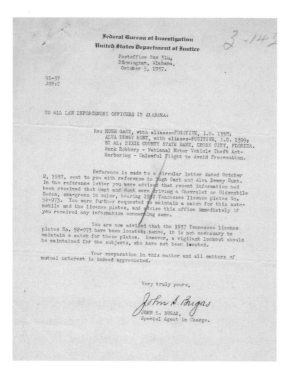

The FBI published a circular on a set of Tennessee plates that had been found. They were known to have been used by Hunt and Gant.

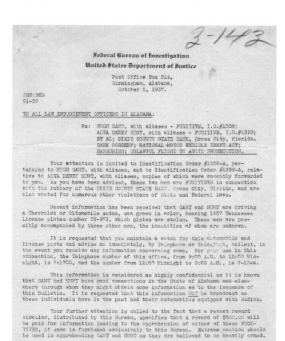

An identification bulletin referenced the stolen plates and noted that Hunt and Gant were "armed and dangerous" and that they employed the use of car radios to intercept police chatter.

Capture

Gant must have known that their freedom was waning, so it is not surprising that the FBI exercised extreme caution in apprehending them, as they were believed to be heavily armed.

Three days after the issuance of the "all points bulletin," the feds sent out another letter regarding the whereabouts of Hunt and Gant. They noted that the stolen Tennessee license plates had been located but that vigilance needed to be maintained because the subjects had not yet been located. The plates or the vehicle most likely would have been dumped during the escape.

Then their freedom ended. The *Tallahassee Daily Democrat* published an article on January 12, 1938, that attested to the pair's rise to the pinnacle of gangsterdom. The headline read "Florida Bank Robbery Suspects in Texas," with the subtitles "Hunt and Gant Face Charges in Two States" and "Are Wanted in Connection with many Banditry, Larceny cases." The story emerged from the Associated Press in Washington, D.C. The FBI "announced two of the nation's most sought after fugitives Dewey Hunt and Hugh Gant" were under arrest in Houston, Texas, in connection with a series of bank robberies in Florida and Alabama. FBI Director J. Edgar Hoover said that "Gant and Hunt were being removed immediately to Pensacola for trial." He ordered the transfer upon receipt of information that the prisoners had signed removal waivers. They were definitely at the center of a manhunt that had intensified several years after G-men had rounded up or killed more notorious men, including Baby Face Nelson, Pretty Boy Floyd, Dillinger and Karpis.

The FBI's admonition to law enforcement to utilize caution was bolstered by what they found in Jackson, Mississippi. The Hunt-Gant hideout was termed a "veritable arsenal" and indeed appeared to be so. A small house perched atop a knoll housed an array of weapons, including fifteen high-powered rifles, automatic shotguns and a massive supply of ammunition. The FBI summary dated March 30, 1938, detailed the weaponry. Inside the Jackson lair, federal agents found a .45 caliber revolver, a .38 caliber, nickel-plated pistol with its identification numbers filed away, a .351 caliber autoloading rifle, a Craig-Jorgenson 30.06 rifle, a Winchester 30.30 and a 20-gauge Winchester shotgun.

In addition, the feds found a 1937 Ford sedan that had been stolen from Dr. Charles A. Born of Pensacola, three doctor's bags and a Red Cross kit. One of the doctor's bags was loaded with ammunition. The Red Cross kit included standard getaway paraphernalia for period bank robbers, which normally contained morphine. Criminals on the run were forced to become impromptu surgeons or at least stave off the pain of a gunshot wound until an underworld doctor could be located.

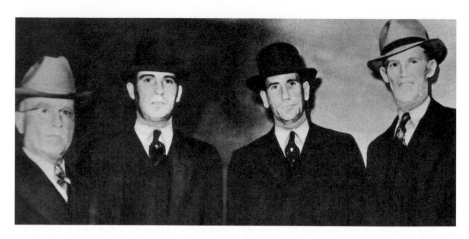

The four main law enforcement officials credited with capturing Hunt and Gant. (*Houston Press*, January 13, 1938)

The building's interior had been modified with a "cleverly constructed catwalk" in the attic, which led to a ventilator connecting to windows that provided a vista overlooking all approaches to the property. Near each opening were two high-powered rifles loaded with dumdum bullets. Hunt and Gant never had to resort to a high level of violence. Recorded acts of violence, from striking bank employees to a carjacking during one escape and possible participation in a knifing, seem relatively tame considering the arsenal of weapons they had stockpiled. However, the intense scrutiny and pressure from law enforcement may have turned the duo toward being prepared to resort to deadly acts.

It is important to note that Dillinger, who was dead, and Karpis, who was then serving a life sentence for the 1933 kidnapping of brewery heir W.A. Hamm Jr., committed numerous murders and crimes of violence. Most other well-known gangsters, in fact, were quick to exchange iron with police. Hunt and Gant committed crimes of opportunity during the first phase of their careers, when they were automobile thieves. During their bank-robbing phase they certainly brandished guns, used kidnap victims for prison escapes and getaways and engaged in high-speed chases. During bank heists they sometimes resorted to violence, especially the Foley, Alabama one, where Gant allegedly struck and injured an employee. However, it is especially important to note that while Hunt and Gant "terrorized the Southeast section of the U.S. for nearly 18 years," no information ever emerged suggesting that Gant or Hunt killed anyone. How they would have reacted had they been caught in the Jackson, Mississippi hideout instead of a car arriving in Houston, Texas, is unanswerable.

Capture

The *Houston Press* and *Houston Chronicle* focused attention on the story that, at the time, gripped the Southern part of the country. With titles like, "G-Men, Police Nab 2 Public Enemies Here" and "Public Enemy Pair No. 1 Are captured by G-Men and Houston officers," the city felt the presence of the Sumter County boys. Houston was the "focal point of the nation for law enforcement" as a result of the capture of "two of the Public Enemies still on the books of G-Men." Alva Dewey Hunt and Hugh Gant, referred to as "Public Enemy Pair No. 1," had been free until "they looked into the guns of Department of Justice agents and police on Airline Road" in the 1600 block section around 7:00 or 7:30 that evening. Shortly after 7:00 p.m., agents Sloan and Fuller sighted the fugitives' car on Main Street near Airline Road. They signaled to Jones as Hunt and Gant turned off Main onto Airline.

The Federal officers crowded the car, pinning it "to the curb with fender-crunching closeness" and ran it into a ditch. Jones lowered his window from the backseat and leveled his weapon at Gant, who was in the driver's seat, while Martindale poked a sawed-off shotgun at Hunt in the back seat. Officers scrambled from the car with Gus T. Jones directing his .351 caliber rifle and Detective C.V. "Buster" Kern a sawed-off shotgun. A.C. Martindale remained behind the wheel of the car. The officers shouted, "Get 'em up."

Allegedly, Gant "almost poked his hands through the top of the car." From the front seat beside Gant, "plump, pretty Mrs. Aileen Hunt tumbled to floor of car." When booked Ailene Bledsoe gave her age as nineteen and her hometown as Malvern, Arkansas, and claimed that she had married Hunt in July of 1937. Hunt slowly raised his hands from his spot in the backseat. The "bank terrorists" showed no inclination to resist capture according to most reports. An alternate report suggested a more likely seating scenario, with Bledsoe and Hunt together in the backseat.

Agents Sloan and Fuller emerged running from their backup car with their guns drawn. They shouted, "Out of it," to the paralyzed fugitives. Gant was said to have replied, "She's in gear." His feet were pressing the brake and clutch to corroborate his statement. Kern ordered Gant to take the car out of gear, but Gant replied, "Not me. Take it out yourself if you want to. My hands stay up." Kern obliged, slipping the gearshift into neutral. Gant got out of the car, but Hunt had to be hustled out. Kern quoted Gant, who said, "Well, it had to end some time."

Neither Gant nor Hunt offered any real resistance. In fact the Houston AP provided insight into Hunt's personality and his relatively nonviolent nature. When G-men searched Hunt, they found $10 in one of his shoes. When asked why he concealed the money, the desperado quipped, "I was

afraid I might get held up." He added, "I figured I could hold onto a little coffee money." He kept an additional $25 in his pant's pocket, while Gant had $18 in his possession. It was a pittance considering the approximately $70,000 they had earned during the last three years of their criminal activities focusing on bank robberies.

The officers handcuffed the trio and recovered a revolver from the seat where Hunt had sat. Inside the glove compartment was an automatic pistol. Alternate reports suggested that the pair each had .45 caliber pistols. The trio was loaded into police cars for the trip to the jailhouse. On the way they passed the spot where Detective Lieutenant Tom Eubanks, Special Agent Winton and others had been patrolling another avenue into Houston, unaware that the public enemy pair had just been captured. Allegedly, one of the gangsters said, "They picked our road, you got a tough break," to the crew as they slowly passed by. The agents took their new captives to the federal building for initial questioning and then to the West End Jailhouse.

After entering the jailhouse, a "thin, bespectacled Hunt protested to giving his glasses up" to the desk sergeant. Hunt stated that it was the "first time I ever had to part with my 'eyes.'" He gave his name as Alva D. Hunt and his age as forty. When asked his address, Hunt replied dryly, "I'm

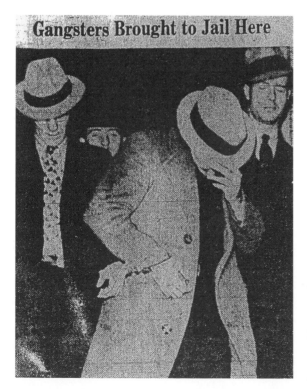

Gangsters Brought to Jail Here

Gant, with his face characteristically hidden from view, and Hunt are escorted to a Houston jail in handcuffs. One of them allegedly told a photographer that he would "kick him in the jaw" for taking his picture. (*Houston Press*, January 13, 1938)

getting one." He may have been anticipating incarceration at Alcatraz. Gant, described as "round-faced" and partly bald wore a "loud red muffler" around his neck. The sergeant asked him why he was hiding his face, and through the scarf the Floridian simply replied: "It's cold."

Later that day they "paced up and down in West End jail cells under the watchful eyes of two husky federal guards." Food was brought in for the agents and prisoners during an initial questioning session. A call went out from agents at the federal building to Hoover, who had been in "close contact with the progress of this case particularly as the case got *hot* a week previous to the capture." An "army of agents" had moved into Houston ahead of the gangsters' arrival. Hoover congratulated them and the Houston Police. "Mr. Hoover's mighty pleased about the capture," remarked Jones. "They are the number one pair of pub enemies on our list. We've been after them 3 yrs."

Special Agent Jones spoke favorably of the local law enforcement, praising Lieutenant Eubanks and Detectives Kern and Martindale. Hoover asked Jones to relay the Bureau's gratitude for their assistance in the capture. A $1,000 reward was pending departmental "determination," though for whom it was intended is unknown. The capture, according to Jones, was the result of 100 percent cooperation, several days of work and "plenty of help." The "help" most likely meant tips from informants, though Jones did not give any hint as to how the case was solved.

It was learned later that Captain Mort Rainey first learned that the outlaws were keeping a rendezvous in Houston from time to time and heard

Two Men Wanted In Eight Bank Holdups Are Captured Here

Public Enemies Nos. 1 and 2 Caught by G-Men and Houston Police After Three-Year Nation-Wide Hunt.

One of many "blazing" headlines proclaimed the capture of the number one and two most wanted gangsters in America. (*Houston Press*, January 12, 1938)

reports that Hunt and Gant had been seen in Houston. He investigated further and turned over the information to the Department of Justice. Much of his information became the foundation of Jones's waiting game.

Jones said that he arrived in Houston one week before the capture and worked a "Houston angle" with Special Agents Sisk and Sloan. Information led Jones and the Bureau to the belief that Hunt and Gant were possibly in Jackson, Mississippi. A check there failed to locate them, but a team of agents staked out the area anyway. Descriptions of two cars with their license numbers were received from an unknown person. One of the vehicles was a Plymouth with Texas license plates. Federal agents determined that the vehicle had been seen in Jackson the night before the capture, but they had lost it. Jones worked on a hunch that "if they were in Jackson last night, they were just as liable to be headed" to Houston as elsewhere. The officers calculated the driving times, decided on an hour to lay in wait and divided patrols to watch the inbound routes to Houston—the Shreveport and the New Orleans routes. The Shreveport route fell to Jones and the city detectives in one vehicle, while agents Sloan and Fuller drew the other.

The capture was the result of a three-year nationwide manhunt for the pair who had "eluded capture longer than John Dillinger or Ma Barker's gang." San Antonio–based federal officer Special Agent Gus T. Jones's fame had already grown due to his capture of master gangster Harvey Bailey and

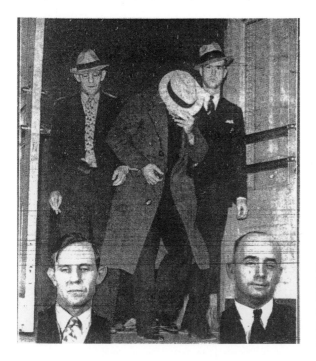

Detective Sloan escorted Hunt and Gant from a Houston jailhouse. Insets show what Gant's hat kept hidden. (*Houston Post*, January 13, 1938)

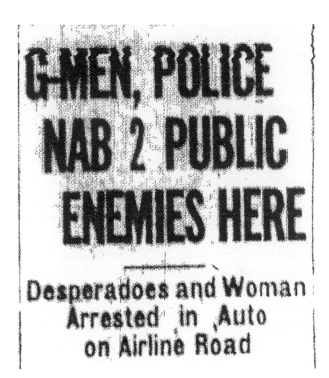

G-MEN, POLICE NAB 2 PUBLIC ENEMIES HERE

Desperadoes and Woman Arrested in Auto on Airline Road

G-men got most of the credit for the capture of Hunt, Gant and passenger Alene Bledsoe. (*Houston Press*, January 12, 1938)

breaking of the Urschel kidnapping case. The capture of Hunt and Gant added to his legacy.

At 3:00 early the next morning, a "police matron was borrowed" to stay with Mrs. Hunt. Later that day, she emerged with Mrs. Hunt, trailed closely by a special agent. Following the ladies were Hunt and Gant, hats pulled down to cover their eyes. They were shackled together and were able to dodge cameramen because of a cordon of agents. One of the fugitives yelled at *Houston Press* photographer Francis Miller as he was snapping a picture, "I'll kick you in the jaw!" Of the two, Gant had demonstrated the propensity for harsh language and was probably the gangster who threatened the photographer. Hunt probably would have "cracked wise" instead.

Bledsoe remained in Houston after the pair was hauled away to Florida. Before they finally left, local police sought to determine their connection to several local Houston robberies. Employees from the Mossler Acceptance Corporation, robbed that December of $800, were brought in to look at Gant and Hunt. They failed to positively identify them and the police cleared the fugitives of any Houston area crimes. Interestingly, robberies in Louisiana and Mississippi were added by the press to their tally, though no information had been uncovered verifying them.

The press was not dissuaded from trying to heap yet more crimes on the pair. Hunt and Gant were suspected in the slaying of Ruby Evans shortly after January 5. No information ever came to light, and neither man was indicted for the killing. Since the murder supposedly took place not long after the Guthrie robbery and killing of the postal worker in Nashville, Tennessee, and because their whereabouts had already been established, they were quickly exonerated of the crime.

On January 13, the *Houston Post* had the number one pair of villains leaving "in irons for Pensacola." Anonymous G-men asserted that the two men captured in Houston topped Dillinger. Surrounded by sawed-off shotguns and government agents, Hunt and Gant were manacled together. It is possible that despite the end of their freedom, a sense of inevitability had set in on the two. During the frenzied end they lived by the rule of staying no longer than about one week in a single place.

They were transported from Houston to Florida by train, and regardless of their capacity for violence and recent christening, the two engendered sixteen guards and massive notoriety. Sixteen officers transferred the "nation's two toughest public enemies" from the train to a Leon County Jail since the jail they were originally brought to in Escambia County was not approved to hold federal prisoners. The five FBI agents who made the trip from Texas to Tallahassee with the "desperados" remained outside the prisoners' cells after the pair was officially arrested in Florida.

Newspapers blazed the headline, "Public Enemies No. 1 and No. 2 Held in Local Jail." According to a Birmingham, Alabama FBI report dated June 9, 1938, Gant was dubbed the nation's public enemy number one and Hunt, number two, shortly before their capture in Houston.

Another newspaper article subtitle read "Bad Man Here" under a picture caption crediting Gant with leadership of the "desperately reckless Florida

Public Enemy Pair No. 1 Are Captured by G-Men And Houston Officers

Both the feds and the press considered Hunt and Gant "Public Enemy Pair No. 1." (*Houston Post*, January 12, 1938)

bandit gang" after Riley Gant's demise. Confirming that Gant was the "bad man" was the almost fleeting mention that "in a separate cell is his pal, Alva Dewey Hunt." Hunt did not escape condemnation, however. The "pair of Florida boys made bad in a big way" and were arrested after an intensive hunt by the FBI.

An AP story, dateline Miami, Florida, related some of the gang's history and introduced its newer members. The capture of Hunt and Gant led to the smashing of the "last remnants of the Florida gang that began operations around 1920." Benny Alvarez and Jack Ray Oliver were implicated in several of the gang's later crimes. Alvarez was currently serving his three-year sentence at Raiford for receiving and possessing stolen property while in Tampa. He was also implicated in the Cross City bank heist. Oliver had just begun serving a twenty-one-year term in an undisclosed federal penitentiary for his role in the same bank robbery.

On January 13, 1938, Gant and Hunt were cleared of involvement in yet another crime. Officials had been investigating a Guthrie, Kentucky mail robbery during which a "negro postal messenger" was killed and an officer was wounded. That crime occurred on January 5, 1938, shortly before their arrest. The thieves responsible escaped with $25,000. Orville C. Dewey, head of the Louisville, Kentucky post office, later related that Hunt and Gant's whereabouts had been established and that they were definitely *not* in Guthrie at the time of the incident. Agent Gus T. Jones acknowledged that neither man was scheduled to go to Louisville for investigation into the case.

The *Post* ran a story on the January 14 about an unnamed Houston man who was held for questioning by the feds for his possible association with the gangsters. The thirty-seven-year-old had been arrested on January 13 by motorcycle officers who had given him a speeding ticket the day before. He claimed to be an oil field worker. The focus of questioning was centered on his knowledge of the Hunt-Gant hiding place. It was revealed that the fugitives had rented tourist cabins near the city numerous times as hideouts. Presumably the connection was that the unnamed man arranged the accommodations and, therefore, was most likely aware of their wanted status.

In another bit of related news, on January 28, 1938, the *Sumter County Times* ran the story, "Death Claims one of our Best Citizens." As an honor to the deceased and those who survived him, the paper ran H.D. Hunt's obituary on the front page. Mr. Hunt was survived by his widow, Mabel Hunt, and five daughters, including Mrs. Eva Thompkins and Miss Myrtis Hunt of Bushnell, Mrs. John Thompkins of Lakeland, Mrs. John Reeser of Bradenton and Mrs. Kester Stewart of Ocala. Other survivors included a stepdaughter, Mrs. Charles Cox of Fort Myers; four sons—Enos, Alva, Harold and Truby of Bushnell; a brother, George E. Hunt of Port Haywood, Virginia; and three sisters.

The Trial

On January 20, 1938, the *Tallahassee Daily Democrat* read, "Gant, Hunt Face Gainesville trial." Jack Ray Oliver and Benjamin Alvarez were indicted along with Hunt and Gant for the Cross City robbery. A warrant had been issued for Oliver on May 10, 1937, for his involvement in that crime, for which Oliver received sentences totaling twenty years. Among the jurors for the Oliver portion of the trial were J.F. Beach, J.W. Bell, W.W. Blitch, F.W. Craigin, A.J. Davis, Zach Deal, Alex Driver, George Highsmith, G. Harry Hopkins, Claude Sparkman and E.T. Usher. B.R. Colson acted as foreman.

Federal Judge A.V. Long, presiding judge of the U.S. District Court for the Northern Division of Florida, was out of the city and the next regular term was not set to begin until June, yet he made an appearance to hold the arraignment and called a special court session to try the duo as soon as federal and defense attorneys were ready. United States Attorney George Earl Hoffman was in town on general business, which included an indictment for the Dixie County bank heist.

Early Monday morning, on January 31, Hunt and Gant were taken from their Tallahassee jail cells and brought to Gainesville. Three federal agents, Sheriff Frank Stoutamire and three additional assistants escorted them to Gainesville in three cars. Twenty-six witnesses were subpoenaed for the prosecution. Among them were victims, special agents and police officers, as well as several expert witnesses. Special Agent Gus T. Jones flew in from San Antonio, Texas, and C.S. Winstead from the Jacksonville office. Special Agents L.A. Newsom and R.L. Shivers of the Miami FBI office appeared. Cross City Sheriff Frank Anderson rounded out the officers for the prosecution.

Gant and Hunt are wanted for the robbery of the Dixie County State Bank, Cross City, Florida, on January 14, 1936. Gant is also under indictment for violation of the National Motor Vehicle Theft Act.

If you are in possession of any information concerning the location of Gant or Hunt, please communicate by telephone or telegraph collect with the undersigned, or with the nearest office of the Federal Bureau of Investigation, U. S. Department of Justice, the local addresses and telephone numbers of which are set forth on the reverse side of this notice.

JOHN EDGAR HOOVER, DIRECTOR,
FEDERAL BUREAU OF INVESTIGATION,
UNITED STATES DEPARTMENT OF JUSTICE,
July 27, 1936. WASHINGTON, D. C.
 TELEPHONE, NATIONAL 7117.

The FBI kept numerous field offices throughout the country, including an important one in Jacksonville, Florida.

Witnesses included two gentlemen from Paterson, New Jersey, a woman from the Blue Lodge Café in Live Oak, Florida, and another from Baker's Grill in Winter Haven. An unnamed gentleman from Jackson, Mississippi, possibly an informant who gave information on the pair's hideout; Reverend William M. Mullen, care of the Methodist Orphanage at Benson Springs, Florida; three witnesses from New Port Richey; two from Brandford, Florida; one gentleman from Madison County; and a woman from Nashville, Tennessee, filled the portion of citizens as witnesses.

Victimized banks sent witnesses as well. B.S. Preston Sr. and B.S. Preston Jr. were present from Cross City, as was S.R. Langston. Mr. Jones was there, care of Mrs. Minnie Jones, as a representative of the Dixie County State Bank. Victims of car thefts included Jack Wood, a representative of Costley Motor Company of Orlando, and L.L. Chilton of the Stockwell Motor Company of Nashville, Tennessee. Joseph J. Foley, secretary and treasury vice-president of Bird-Sykes Company of Chicago, was there as an expert witness to present data, ledger sheets, invoices and records pertinent to a Graham Sedan Motor car that was identified in the defendants' possession in New Port Richey on January 2, 1936.

Despite the large number of witnesses, the pair pleaded innocent at the arraignment and Judge Long scheduled the trial to begin on Monday, February 7. According to reports, the duo presented a "dapper appearance" during the arraignment as both men dressed in dark blue suits and wore black oxfords and gray felt hats. Gant wore a white dress shirt while Hunt chose blue. Charges included "knowingly, unlawfully, and feloniously by force and violence" taking money from the Cross City bank and for striking the cashier and wounding a customer, as well as a travel in interstate commerce violation from Cross City to Carthage, Tennessee. They were returned to Leon County Jail shortly after lunch.

The same afternoon, the twelve-person jury was selected out of a potential juror pool of twenty-six. Jurors for the Gant and Hunt portion of the trial included A.V. Benson, B.C. Bishop, H.C. Chandler, B. Clark, H.L. Coles, O'Neal Cox, W.C. Evans, Eugene Henley, M. Dell Love, B.F. Mizell, L.S. Newsome and Earl V. Simpson.

Hunt and Gant were continually transported under heavy guard. U.S. Marshal E.M. Sessoms, three deputy marshals and five special agents typically accompanied the two on the ride to the trial. In all, U.S. Attorney Hoffman called twenty-five witnesses for the government. George C. Dayton, of Dade City, Florida, was the defense attorney. He, however, did not summon *any* defense witnesses. Assisting George was his father, O.L. Dayton (a former circuit judge), and Clark Gourley, a local Gainesville attorney. Spectators crowded the corridors to catch a glimpse of the two nattily dressed gangsters. When testimony began the courtroom was crowded and quiet.

Attorney Hoffman's opening statement offered the expectation of proving five counts—stealing currency, taking it by force and violence, assaulting a cashier, assaulting a patron and crossing interstate lines to avoid prosecution. Unbelievably, the next day defense attorneys "dropped the case," leaving Hunt and Gant to defend themselves. Though there is no information regarding the reason for the attorneys' decision, Gant and Hunt said that the separation was mutual. The surviving copy of the motion has been defaced by an unknown person, but visible through the scratches was seen "by their undersigned attorneys" replaced with in "their own proper persons," evidence that Hunt and Gant defended themselves. The third page had spaces for the representing lawyers from the Dayton firm and Clark Courley to sign. In place of the attorneys' names, however, the signatures of Alva Dewey Hunt and Hugh Gant appeared.

Seven witnesses testified that Hunt and Gant had inquired about the back roads on the day of the Cross City robbery. They also agreed that the gangsters had forced Miss Elma Rowe of Lee, Florida, to exchange cars on the evening of the heist. A.C. Murphy provided a list of banks insured by the FDIC as of January 14, 1936. Among the banks was the Dixie County State Bank. Verification was provided for Dixie County State Bank's ability to perform as a business dating back to 1923, with a document bearing the FDIC seal dated 1933.

Hunt conducted a cross examination of the state's witnesses, "attacking" the veracity of them positively identifying the car allegedly used in the Cross City bank robbery. Each man made short arguments before the jury after they informed Long that neither would take the stand in his own defense. They added that they had no witnesses. Gant, in closing, attacked

GANT AND HUNT PLEAD INNOCENT AT GAINESVILLE

Hunt and Gant pleaded innocent, which may have led to the mutual dissolution of the partnership between the lawyers and criminals. They ultimately defended themselves. (*Tallahassee Daily Democrat*, January 31, 1938)

the government's witnesses who had made identifications, while Hunt dealt with witness testimony that claimed they had seen the pair driving away from the bank.

After the prosecution had concluded its case, Hunt requested the court to direct the jury to return a not guilty verdict on all of the counts. Hunt listed six reasons to bolster the opinion that a not guilty verdict should be found:

1. That the government failed to prove all of the material allegations.
2. That it was unconstitutional for Congress to provide a punishment of an "insured bank," especially since the State Banking Association was not employed by the federal government.
3. That the first two counts were, in fact, the same offense.
4. That the government failed to prove force and violence on the first count.
5. That the government failed to prove putting "fear" into the second count.
6. That the government failed, as well, on the fifth count.

Despite Hunt's closing, the jury took less than ten minutes to render the guilty verdict for the Cross City bank job. Foreman Mizell delivered a handwritten slip bearing their decision. During the sentencing Judge Long asked that the pair be confined, "preferably in Atlanta." Most important to

Hunt, Gant Guilty; Sentenced to Prison For 25-Year Terms

$2000 REWARD OFFERED FOR BANK BANDITS

Police, Sheriff Stamp Gant No. 1 Enemy

Above: The press trumpeted the first of two long sentences Hunt and Gant received. (*Tallahassee Daily Democrat*, February 8, 1938)

Left: Another reward offered for the capture of Gant. Some were paid out to gentlemen from Mississippi and Texas who provided evidence that led to the capture. (*Tampa Sunday Tribune*, March 8, 1936)

the gangsters was the term of the sentence. When asked for any last words before sentencing Gant said, "I owe a debt to society and I'm ready to pay it. But I hope the sentence won't be too long. I have a wife and child and I don't want to spend my life in jail."

The court sentenced both men to ten years for the first two counts to run concurrently. They received fifteen years for the third and fourth counts and an additional year for the fifth. The final three counts were set to run concurrently and to begin immediately after the expiration of the ten-year term for a total of twenty-six years. The sentencing initially made them eligible for parole on June 8, 1946, with the term expiring potentially on

November 22, 1954, with good time earned for excellent behavior. The full extent of the sentence was to culminate on February 8, 1963. Alva Hunt was delivered to USP Atlanta on February 9, 1938.

Rewards were paid out at the culmination of the trial. Attorney General Cummings awarded $500 to J. Wood Harpole of Jackson, Mississippi. Harpole identified a picture of Hunt as a tenant in a home in Jackson. D.M. Wrotenberg of Lufkin, Texas, also received a reward. Wrotenberg recognized a photograph of Gant in a Houston newspaper and thought it was identical to a person living in Houston. Each man gave information to the Justice Department. The attorney general said that the information they gave was extremely "instrumental" in leading to their capture.

An AP story on March 28 recounted that two women visited Gant while he was being held in a Mobile, Alabama county jail awaiting additional charges for the Foley heist. Hunt had preceded him there for similar charges, pleaded guilty and was sentenced twenty additional years in Atlanta. The women were arrested and held under $10,000 bond for harboring Hunt and Gant during periods before and after the Foley, Alabama robbery. Federal District Attorney Francis H. Inge said that Audie Lee (Cotton) Gant, Gant's twenty-one-year-old wife, and Mary Black, Gant's twenty-nine-year-old sister were both residents of Houston. Gant was sentenced by U.S. District Judge John McDuffie to receive an additional twenty years for the Foley robbery.

An interesting note that may not be verifiable was that during his incarceration between sentencing for the Cross City and Foley robberies, Hunt had not had the "privilege of seeing his son Alva Hunt." "Alva" had been detained in Pensacola in connection with the theft of an automobile. Conflicting information lists an Alva Hunt Jr. as seventeen years of age per a July 1936 wanted poster. It is known that Alva Hunt had one child, named James A. Hunt, and that Katherine Hunt, of Houston, Texas, was the mother. No information confirms that Hunt's child was named Alva Jr. or that he was ever involved in automobile thievery. James A. Hunt went on to have a successful career in the oil industry and eventually established a peaceful relationship with his father.

Legal wrangling by the prisoners and their lawyers reduced the cumulative sentence from forty-five to forty years on November 15, 1946. The final sentence had a minimum expiration date with excellent behavior of July 8, 1964, and a maximum of February 7, 1978.

Alcatraz, Leavenworth and more

For most Floridians, as long as criminals were "kept from public view while being punished," the system was effective. The period was one of punishment rather than rehabilitation. Hunt and Gant saw a wide range of jailhouses, prison farms and workhouses and, eventually, hardcore penitentiaries. One such facility included Alcatraz, where Gant was transferred after a brief stay in Atlanta.

The Department of Justice described Alcatraz in fearsome terms:

> *Tool-proof steel has replaced the old soft steel fronts. Automatic locking devices have been put in place.*
>
> *Teargas outlets were provided and a special group of trained, experienced guards was recruited from the other Federal penitentiaries. A zone in the water was marked with buoys into which boats are forbidden to enter. An automatic gun-detector records the presence of metal on the person of any person who passes the barriers. New guard towers were erected, flood-lights put in place, and additional barriers built around the 75-foot cliffs of the island. Gun-galleries at each end of the cell-blocks control the interior of the building, while the island is controlled by a system of towers connected by overhead walks.*

Hugh Gant was transferred from United States Penitentiary Atlanta to USP Alcatraz. Gant, who became number AZ-444, was transferred due to his "long record of serious crime and violence" that dated back as far as 1920, according to the feds. In addition to his two prison escapes, a psychological profile showing him to be a "persistent, intractable criminal in need of maximum custody" convinced a committee that he should be

removed from the general population of Atlanta. He had no violations reported from USP Atlanta during his abbreviated stay, and the only negative mark on his record while at Alcatraz was one instance of possession for contraband. The contraband turned out to be a bolt and nut that could have been used for defense purposes.

Gant's Atlanta Admission Summary, with registration number 52889 and dated February 21, 1938, summarized his tally of crimes. In addition to his social and personal details, results of a physical exam and mental profile acted as references for his change of venue. The interviewer recommended maximum custody and suggested that no transfer was necessary. Though admitted to USP Atlanta, a transfer to Alcatraz was indeed quickly recommended. Gant's time at Alcatraz was most likely characterized by a grueling mixture of regular routine divided by bursts of intense violence. Hunt's stay at Atlanta was probably only a little less so.

On September 21, 1948, Gant was authorized to ship sixty-three photos he had collected over his ten years while at Alcatraz, express collect. They were posted at ten dollars and were sent to Mrs. Marjorie Morton, a married sister in Houston, as part of his preparations for transfer to Leavenworth. A list of items owned by Gant upon transfer from Alcatraz to Leavenworth included 25 "M.R. photos" and "63 S photos, a case and a pen noted as "cheap." He was able to keep a special Schaeffer pen and earphones. In addition, Gant had four envelopes of legal papers, a dictionary and glasses in a case. On the September 23, C.E. Cooper, associate warden to the custody supervisor at Leavenworth, issued a special letter noting that Gant, then christened number 65282-L, was permitted to retain the Schaeffer pen he purchased while at Alcatraz. The pen proudly bore the number 444, Gant's Alcatraz designation. Gant was notified that he was responsible for keeping the letter proving his right to possess the pen while at Leavenworth.

As he settled into a new routine at a new institution, he began to experience the travails of aging but continued efforts to find a legal way out of jail. He began to purchase denture baths and massive legal volumes and specific case law. While there he began to work in the shoe factory. The Special Progress Report issued upon Gant's transfer to Leavenworth listed him as forty-seven years of age and weighing 143 pounds. According to the report, Gant was experiencing mild pain from an appendectomy and had contracted gonorrhea in 1925. He denied ever having syphillis and exhibited no indications of a history of addiction to drugs.

Gant was eligible for a conditional release, with the addition of extra good time, on March 18, 1964. The section on his social history listed one divorce, obtained by one of his wives in Houston on January 20, 1940. He stated that he had been married previously to Thelma Parham and Ida Lee

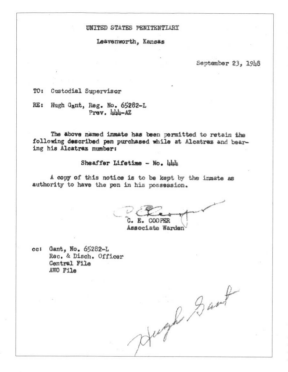

UNITED STATES PENITENTIARY

Leavenworth, Kansas

September 23, 1948

TO: Custodial Supervisor

RE: Hugh Gant, Reg. No. 65282-L
Prev. 444-AZ

The above named inmate has been permitted to retain the following described pen purchased while at Alcatraz and bearing his Alcatraz number:

Sheaffer Lifetime - No. 444

A copy of this notice is to be kept by the inmate as authority to have the pen in his possession.

C. E. COOPER
Associate Warden

cc: Gant, No. 65282-L
Rec. & Disch. Officer
Central File
AWO File

Gant favored his special Schaeffer pen inscribed with his Alcatraz prisoner number.

Burke and that he had no children by either. His sisters and their husbands were listed, including Katherine, Alva Hunt's first wife, who was remarried and living in South America.

The only evidence the report showed of his Alcatraz incarceration was his occupation as a janitor. It confirms that he had enlisted in the navy on August 20, 1917. Sadly, the report demonstrated that by that point Gant had become resigned to staying incarcerated for the remainder of his life. Gant was not recommended for work that paid due to a question on his lack of dependability. His vocational history was nonexistent at Atlanta since the stay was brief. His ten-year stint at Alcatraz listed the laundry as the workspace where he performed janitorial duties. Gant expressed an interest in an industrial assignment, but he had developed no special skills. It was determined that he was capable of performing "average factory work," and he acknowledged that work in the brush or furniture factory sounded appealing. Gant's life had never been a religious one. He indicated that he had only gone to Sunday school a few times in his formative years, never became a church member and did not attend chapel at Alcatraz.

His next report in December of 1949 reiterated much of the above and indicated that he was making average adjustments with his work as a shank stitcher in the shoe factory. He had spent the last fifteen months working

there since leaving his original assignment in the brush factory. Gant completed a course in industrial safety but showed no further interest in broadening or expanding his education. The report, detailing every aspect of the prisoner's life, noted a correspondence from an unidentified sister. The letter indicated her interest in Gant's welfare, and she inquired about the regulations for visiting at Leavenworth. That year Gant prepared an affidavit to be mailed to a "co-defendant" at USP Atlanta in an effort to help the codefendant in a legal action.

Gant's 1951 report showed that four hundred days off for industrial work in the brush and shoe factories had advanced his conditional release date from December of 1964 to November 1963 for good behavior. Despite his impeccable conduct record, a detainer was filed by Florida officials regarding his Raiford escape. Again he received positive reports for his vocational time.

Happily, Gant was visited for the first time since his transfer by his sister Marjorie. She visited twice, once in July and again in August of 1950. Marjorie stated that she had not seen her brother in ten years. Gant's plan upon release was to live in Texas, though he had no plan for a line of work. Parole was denied in 1950 with no recommendations of adjustments to his program.

Gant was fifty-two years old when his 1953 progress report was issued. He was still working in the shoe factory and was receiving outstanding work reports. He had progressed to an inspector's position in the stitching department and was described as a "dependable and reliable worker" with an excellent attitude. During the year he had occasional contact with a parole officer and some correspondences with authorities relating to his criminal case, and he had received eight visits from a sister living in New Mexico. An appeal for executive clemency in 1952 had been denied.

In 1955 a parole hearing was executed. Gant was, by then, listed as a "superior" worker having spent the last six years in the shoe factory. He had added the cripple runner position to his inspector role. He expressed no interest in educational or religious programs. It was noted that he was still receiving "regular visits" from members of his family. At one point he made a seventy-five-dollar withdrawal to help an unnamed sister "in need." Gant made no immediate plans for release, correctly feeling convinced that Florida authorities would not withdraw the detainer for his escape.

The 1956 report did not show much change. His work life improved and impressed prison officials, and he continued correspondences with family, though he had not been visited recently. The annual review noted a minor operation for skin lesions that turned out to be benign. The 1957 report was similar, with the notable exception of visits from his sisters Mary and Helen in November and Marjorie in December. Correspondences continued with

Gant's work at Leavenworth Federal Penitentiary netted him money to save and to send to his sisters.

family, and possibly with a child. The information is made indecipherable in the existing documentation but is strongly suggestive that one, or more, of his children were in contact.

By the following year, Gant's release date had advanced to August 30, 1962. He received a yearly visit from two sisters from Texas. The 1959 annual review showed that Gant's release date moved to July of 1962, and by the following year, he had cut his time to May of 1962. His dedication to his job garnered him being considered "cooperative" and "productive." His cell was kept in a neat and orderly manner and he abided by the rules. Gant, by this time having been incarcerated for twenty-two years, had spent a major portion of his life behind bars and had assimilated into the prison culture well.

His next report, dated May 1961, indicated another parole denial and that he had filed a motion in the U.S. District Court in Gainesville seeking to have his Florida sentence vacated. The year brought a Prerelease Review. Gant, then sixty years old, was now due to be released in January of the following year. His plan had changed from relocating in Texas to returning to Webster, Florida. Besides it being his place of birth, it was the "only place he has any friends" and relatives. While that seems disputable, at least Gant had a plan. He intended to work as a laborer on a truck farm and would have over $2,700 in bonds and personal funds upon release. The plan, of course, was contingent on the vacating of the detainer from Florida.

His release plan to settle in Webster was accepted by the U.S. Probation Office in Jacksonville, as his transfer to Tallahassee approached. Florida probation authorities stated that they would execute a warrant regarding the Raiford escape but reserved the opportunity to present a plea to the pardon and parole board.

A probation officer accepted supervision of Gant upon his release with the thought that friends and family could visit him more regularly in Tallahassee and he would have a chance to "taper off" in his home state. A letter from a record clerk at the Commissioner of Agriculture's Prison Division had a handwritten note at the top regarding Gant's eventual transfer to Tallahassee. The letter of detainment cited the *State of Florida versus Hugh Gant*, number 24805, for his escape. Florida requested a thirty-day notice prior to Gant's release from Leavenworth.

Upon his transfer from Leavenworth to Tallahassee on December 12, 1961, Gant's possessions included a dictionary, six books noted as law-oriented, one treasured bundle of letters and cards, three photos and his eyeglasses. On December 13, he was transferred and received yet another designation, number 19125-TF. With 4,800 special good behavior days and 1,064 extra good behavior days accrued his maximum incarceration was set as August 11, 1977.

In reality he was released January 24, 1962, through mandatory release and was supposed to be under supervision until 1978 His trail runs cold, but at some point he made his way back to Webster, Florida, leaving few details of the remainder of his life.

Nearly the end of his life behind bars, the State of Florida accepted Gant into a prison in Tallahassee in 1961. He was to serve out the rest of his term that was cut short years earlier upon his escape from Raiford State Prison.

Legal Wrangling

The legal wrangling associated with the Hunt-Gant crew was broad and long lasting. Spanning the 1940s, 1950s and 1960s, Hunt and especially Gant became adept and well versed in the terminology of law.

Benjamin Alvarez received a reply to an inquiry dated May 3, 1939, from a Mr. Carter of the Department of Justice at the U.S. District Court for the Northern District of Florida in Pensacola. Enclosed was a "praecipe for nolle prosequi," or a writ by the clerk of the court declaring that the prosecutor planned to drop all or part of an indictment regarding the case file against Alvarez. Marion Howe, chief deputy clerk, signed the letter that essentially exonerated Alvarez from involvement in the Cross City case.

On May 11, 1937, a warrant was issued to move Jack Ray Oliver, alias J.D. Scrivener from Jacksonville to Pensacola. Oliver gave the required nominal bail in the sum of ten dollars before the U.S. District Court for removal to Jacksonville on June 7, 1937. He was then received into jail at Duval County. Oliver pleaded not guilty on December 14, 1937, for any involvement in the Cross City bank robbery, and the commitment was issued the same day. He was delivered to USP Atlanta on the December 18, four days before the commitment was returned. His penitentiary preference was Atlanta due to its accessibility to relatives living in the Jacksonville, Florida area.

Eight years into the sentence, Oliver sought a correction to his sentencing. Because it was seen, from Oliver and his lawyer's perspectives, that charges one and two "merged" with the third count, and because the first two counts were considered lesser offenses to the third, they essentially amounted to one single crime of robbery.

On April 2, 1943, Robert W. Durden, commander of the National Veterans Association of America, penned a letter to the clerk of the court

at Gainesville. The letter sought a parole meeting, at the request of Oliver's mother, since her son was a World War I veteran. Jack Ray Oliver, Durden noted, was "convicted in your court in 1936 or 1937 for bank robbery." Interestingly, the bank cited was one at Ray City, Florida. There is a Ray City in Berrien County, Georgia, or perhaps Ray City was confused for Dade City. On April 6, Durden requested a copy of Oliver's case and enclosed money for payment in reply to a letter written by Assistant U.S. Attorney S.L. Scruggs.

Oliver petitioned to correct his portion of the sentencing "nunc pro tunc," literally meaning "now for then," on January 11, 1945. The document listed a bond on the back page set at $25,000. U.S. Attorney George Earl Hoffman filed a correction based on the request by Oliver, reducing his total sentence by suspending the first two counts. Counts three, four and five were merged and totaled fifteen years to run concurrently and retroactively.

With Alvarez and Oliver receiving some measure of legal amendments the opportunity was there for Gant to attempt a change in his sentencing. While at Alcatraz, on June 25, 1946, Gant made a motion to vacate counts three and four. He stated that the facts described in counts three and four were insufficient for making an aggravation charge, and additionally suggested that the first four counts, in actuality, comprised one crime.

On July 1, 1946, Gant filed a motion for resentencing, contending that the original ten-year sentence imposed on count one should have expired October 29, 1944. His rationale was that the sentence, which commenced February 8, 1938, had been reduced to the point of its conclusion because of the twelve hundred days of statutory good behavior time he had accrued. In addition, his motion contended that the District Court did not have the jurisdiction to increase, as he saw it, the punishment for count one after Gant had already satisfied the sentence. Gant argued that the point was never raised in the sentencing court and that Gant was not present at the time of the resentencing and did the work as his own legal representative. He requested that the fifteen-year term for counts three and four be vacated. Gant cited over fifteen examples of case law in support of his motion. He wrote his address as Post Office Box 444AZ, Alcatraz, California.

On September 30, 1946, Gant's request to vacate was answered by U.S. Attorney Hoffman and Assistant U.S. Attorney Hollis V. Knight. In the reply, the United States admitted that the offenses charged in the first four counts did in fact constitute one offense but that they could be separated. They denied that the sentences rendered on the third and fourth counts were excessive and that there was overlap of the sentence. They also denied the contention that the prosecution failed to prove aggravation in charges three and four, citing that the testimony in the record demonstrated clearly

that an assault had been committed by the use of a dangerous weapon. The United States suggested that the petitioner's motion, taken as a whole, questioned the validity of the whole sentence.

On November 15, 1946, Judge Augustine V. Long signed a reply to Gant in which Long denied Gant's motion for correcting his sentence. In the denial was the opposition, "Sibley, Circuit Judge, dissents." Acting speedily Gant replied four days later, stating that his general sentence of fifteen years, from which his appeal was taken, was incorrect for two reasons. First, on November 15, 1946, the District Court at Gainesville erred by denying his motion to vacate counts three and four, and secondly, it blundered in rendering a general sentence of fifteen years after Gant had already satisfied two ten-year sentences. Gant's conclusion suggested that he was essentially being put in double jeopardy.

On November 25, Gant requested official records in preparation for another appeal. Among the records were the indictment, the judgment of sentences, his motion to vacate the third and fourth counts plus the order for correcting his sentence, notice of appeal and an assignment of errors. The assignment of errors comprised points on his November motion to vacate.

Gant received the first of many letters from Mrs. Pixie Hampton, deputy clerk of the U.S. District Court in December of that year. In it, Hampton acknowledged his request, assigned a fee and added a postscript that Gant's records needed to be in New Orleans within forty days after the notice of appeal. Gant, in a handwritten letter from Alcatraz dated December 5, 1946, asked for an extension of time. He requested Warden Johnston to mail the check for fifty cents to Gainesville to cover expenses for preparing and certifying the record of appeal. Gant later suggested that the check might have ended up arriving late because the disbursing officer in San Francisco is "very slow making and mailing checks." He requested a thirty-day extension and cited rule thirty-nine in support. Despite all his efforts Gant received no changes to his sentence.

In a handwritten letter dated September 17, 1954, Gant sought to purchase a certified copy of the court order he had acted on years earlier. It was the same court order entered November 15, 1946, in which he requested a reduction of his sentence. A note at the bottom, "memo mailed" to defendant dated September 17, 1954, stated that the order would cost fifty cents. Another communiqué stated that the money had been received and the order mailed on October 1 of that year. Pixie J. Hampton initialed the request. Gant's check request for the fifty cents listed his name erroneously as Hugh Grant, prisoner number 65282-L. On January 21, 1955, Gant inquired of Hampton if she had received the check.

Still doggedly pursuing a correction in the sentencing, Gant filed a brief to refute what he considered to be an illegal sentence. The brief

was dated February 1961. He contended that the original sentence was illegal and invalid, and he again stressed that the District Court did not have the jurisdiction to increase the punishment on count one after he had already satisfied it, and noted again that he had not been present at the re-sentencing in Foley, Alabama. In his argument Gant stated that the twenty-five-year sentence imposed by the U.S. District Court for the Southern District of Alabama should have expired on June 25, 1945, considering the accumulation of over thirteen hundred days of statutory good behavior time. He had accrued an additional three thousand days off of his sentence for good behavior and nearly one thousand days off for industrial work by 1961.

According to Gant that would have made his sentence expire on November 1, 1959, but because of the invalid resentencing his punishment was actually *extended* four years, making him eligible for release in March of 1962. He concluded that the findings were important for other citizens of the United States and complained that he had been denied his rights guaranteed by the Constitution.

More likely, it would have been good for Gant, but the numbers did not work that way. For the Cross City robbery he was sentenced a total of twenty-six years. With the additional twenty years from the Foley robbery, his sentence increased to forty-six years, making the sentence run its term by 1984. His misunderstanding of law in general and the concurrent sentencing structure in particular lent to his continued miscalculations. The Foley addition was not a concurrent sentence to the original twenty-six years.

On June 7, 1941, Hunt made a request to the clerk of the U.S. District Court at Pensacola for a copy of the motion to dismiss the charges made during the trial. On May 25, 1944, Alva Hunt sent a handwritten letter to Mrs. Hampton. Hunt had inquired in a previous letter about the date the Federal Deposit Insurance Corporation became operative on the Dixie County State Bank. Hampton replied that she did not know the exact date, but that it was in 1933, before the Hunt-Gant combine robbed the bank.

On February 5 of that year, Hunt's legal wrangling continued. In a handwritten letter to the U.S. District Court, Hunt asked for a price quote for a copy of the motion and judgment in the case of *Jack Ray Oliver versus the United States*, rendered January 1945. He signed the letter "respectfully yours," Alva D. Hunt number 52888 Box PMB.

On April 10, 1946, Hunt and two "witnesses" signed a petition citing the Jack Ray Oliver ruling handed down in January of the year before. It is possible that Hunt had communicated with witnesses Gant and Oliver. On May 8, 1946, Hunt filed a petition similar to that of Jack Ray Oliver,

based on the findings and changes to Oliver's sentence. An order to correct his sentence was entered on May 31, 1946. The writ pitted Hunt against Warden W.H. Hiatt and cited Alabama Criminal case 9631 and the judgment made at Mobile on March 25, 1938. In essence, he stated that he was being held illegally in violation of the sixth amendment. According to Hunt, his twenty-five-year term was reduced to fifteen years on May 31, 1946. With the accumulation of statutory good behavior time, he claimed that the Florida portion of the sentence had been completed.

In addition, Hunt claimed that he had been "placed incommunicado except for a co-defendant in the cell next to him" upon his removal from Atlanta for the Alabama trial. The only people he spoke to were an FBI agent and a U.S. District Attorney. Apparently he contacted "some lawyer" to get notice to his relatives in Florida, as he hoped they could find him representation for the trial. He received no reply and questioned if the letter to his family was ever mailed at all. U.S. Attorney General Cummings was allegedly at the jailhouse and Hunt requested to speak with him. He felt uninformed regarding the charges and was not even given a copy of the Alabama indictment. He met with Cummings and acquired some of the information.

Supposedly, Cummings was not exactly sure about the charges and only knew that they were in regard to the Foley bank robbery and contained several counts. Cummings inquired how Hunt was going to plead. After a lengthy discussion Hunt, who claimed he was innocent of the Foley robbery, figured that pleading guilty would be a more prudent avenue considering his recent conviction. Apparently Cummings "said he doubted" Hunt's innocence, but that considering the duration of the Cross City sentence, leniency could be expected if he was found guilty. Conversely, if Hunt pleaded not guilty a long and expensive court case would probably have ensued. With that in mind, judge and jury might not have been lenient. While Cummings did not make any guarantees, according to Hunt, he intimated that a maximum of ten years to run concurrently with the Florida sentence was likely. A misunderstanding occurred between the two, but whether Cummings deliberately misled Hunt seems unlikely and cannot be resolved. Hunt claimed that Cummings said he would speak to the judge and noted, "Under this, what proved later to be an erronious [sic] understanding, I entered court."

Hunt's writ detailed the proceedings of March 25, 1938, when he faced the Foley bank heist charges. Hunt claimed that because the indictment was read in court in such "rapid fire order" and because of the writing of the writ, he was still unsure about its contents. Confusion ensued when he was asked how he was going to plead after the reading. Hunt claimed that he

attempted to explain his plea without embarrassing the court or the attorney. Then he pleaded guilty, at which point his "silent lawyer" denied the charges and suggested that Hunt had "misconstrucd statements," possibly those of Cummings. Armed with sudden, new information from his attorney, Hunt asked to change his plea. The request was immediately denied.

Hunt was later asked if he had assaulted anyone during the Foley bank robbery and he replied that he did not. The court withdrew the assault charge and sentenced him to twenty years to run consecutively with his Florida sentence. The writ notes that he was confused and despondent at that point. He did indeed mention that he had been led to believe that the guilty plea would garner a lesser sentence. However, Hunt also suggested that the court had "acted in good faith" and that the judge, John McDuffie, showed him "courtesy in helping him gather" information that became the foundation for the writ he composed in 1948. The only problem, as Hunt saw it, was that he had not been informed of his right to have representation.

This last point seems contradictory in that, according to his own words, he had attempted to send a letter to his family to obtain legal representation. Hunt listed other concerns in the writ. Among them were a question about his legal right to withdraw his plea, his lack of funds to obtain a lawyer and his involuntary pass on counsel. To his credit, he referenced a court case in the writ where an immediate change of plea was granted and other cases where defendants had to be made to understand the charges.

Conclusion

In their entirety the Hunt-Gant combine, by whatever name, accrued thousands of dollars in fenced and stolen automobiles and parts, and many more thousands from bank heists. Unknown quantities of loot and cash were taken from post offices, through store and warehouse robberies and possibly by safe burglaries. They were involved in at least one shootout and a possible knifing, were accused of arson and kidnappings, led car chases and were even erroneously accused of a murder.

Their travels took them from central Florida to all points throughout the state, into Georgia, Alabama, Mississippi and Texas. At different times in their careers they lived or hid out in disparate states like Tennessee, Michigan, Kentucky and possibly California. Hunt and Gant were known to have visited Hot Springs, Arkansas, a protected city that housed gangsters from around the country. It is possible that they employed Joplin, Missouri, as a protected city as well.

Along the way the boys married at least five times. They fathered several children—in Gant's case their names and numbers are in question. They served sentences and were held in small jailhouses throughout Florida, and worked in the brutal convict lease system that brought notoriety to the South. Not all of the prisons held Gant. He escaped from one Florida work camp and an Alabama jailhouse. Surely the criminal period of their lives was as exciting as their incarcerations were lengthy. Each man served long terms of drudgery and slowly began to fade as age, a harsh lifestyle and rugged prison conditions took their toll. Both men returned to Sumter County at some point and are each buried there.

In Hunt's case he melted back into Sumter County society and became a businessman. Hunt is well remembered by relatives as a humorous and lovable man. Gant's descendants are unknown or were uncommunicative.

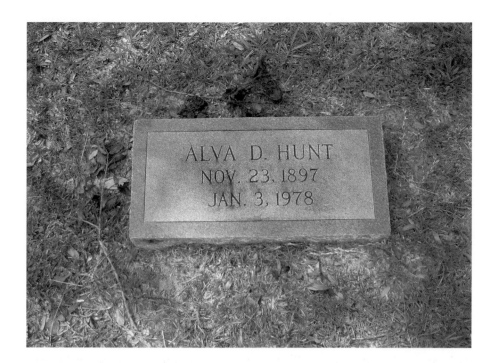

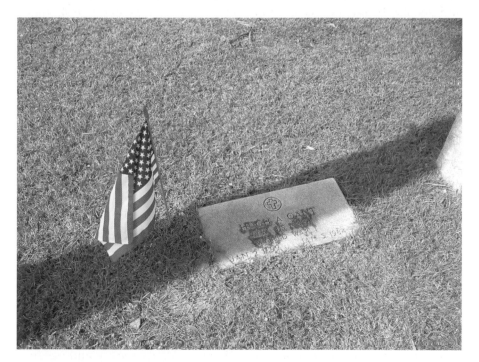

This page: The simple stones mark the resting places of Hunt and Gant and belie the tumultuous times they lived through.

An anecdote holds that years after their lives of crime had passed and both men were aged and becoming feeble, they simultaneously arrived at the Florida Bank of Bushnell one day. Hunt made daily deposits of cash because of his service station business, and Gant was there for some personal business. Each man got out of his car and then they spotted each other, old partners in crime. They must have seen their pasts come alive, if only briefly. As it was, they caught each other's eyes and laughed. What would they have done had it been the 1930s instead of the 1970s, had they been in their thirties instead of their seventies?

Bibliography

Books

Bacon, Eva. *Orlando: A Centennial History.* Chuluota, FL: Mickler House Publishers, 1977.

Bergreen, Laurence. *Capone the Man and the Era.* New York: Simon and Schuster, 1994.

Biffle, Kent. *A Month of Sundays.* Denton: University of North Texas Press, 1993.

Blackman, William F. *History of Orange County.* Chuluota, FL: Mickler House Publishers, 1927.

Bonsor, N.R.P. *North Atlantic Seaway: An Illustrated History of the Passenger Services Linking the Old World with the New.* 5 vols., rev. ed. Brookside Publications, 1975–80.

Brown, Canter, Jr. *In the Midst of All That Makes Life Worth Living, Polk County, Florida, to 1940.* Tallahassee, FL: Sentry Press, 2001.

Burnett, Gene M. *Florida's Past. People and Events that Shaped the State.* Vol. 1. Sarasota, FL: Pineapple Press, 1986.

Burrough, Bryan. *Public Enemies: America's Greatest Crime Wave and the Birth of the FBI, 1933–1934.* New York: Penguin Press, 2004.

Carson, Ruby L., and Charlton W. Tebeau. *Florida From Indian Trail to Space Age. A History.* Delray Beach, FL: Southern Publishing Company, 1965.

Cody, Aldus M., and Robert S. Cody. *Osceola County: The First 100 Years.* Self-published, 1987.

Collins, Frederick. *The FBI in Peace and War.* New York: G.P. Putnam's Sons, 1943.

Cooper, Courtney Ryley. *Here's to Crime.* Boston: Little, Brown and Company, 1937.

Cooper, Courtney, Ryley. *Ten Thousand Public Enemies.* Boston: Little, Brown and Company, 1935.

Corey, Herbert. *Farewell, Mr. Gangster!* New York: D. Appleton-Century Company, 1936.

Cox, Merlin, and Charles Hildreth. *History of Gainesville, Florida 1854–1979.* Gainesville, FL: Alachua County Historical Society, 1981.

Davis, Jess G. *History of Alachua County, 1824–1969.* N.p., 1969.

Davis, Jess G. *History of Gainesville Florida.* N.p., 1966.

Edge, L.L. *Run the Cat Roads.* New York: Dembner Books, 1981.

Fuller, Walter P. *This was Florida's Boom.* Reprinted from the *St. Petersburg Times.*

Gannon, Michael. *Florida. A Short History.* Gainesville: University Press of Florida, 1993.

Gentry, Curt. *J. Edgar Hoover The Man and the Secrets.* New York: W.W. Norton and Company, 1991.

Gish, Anthony. *American Bandits.* Girard, KS: Haldeman-Julius Company, 1938.

Godwin, John. *Alcatraz: 1868–1963.* Garden City, New York: Doubleday and Company, Inc. 1963.

Helmer, William, and Rick Mattix. *Public Enemies: America's Criminal Past, 1919–1940.* New York: Facts on File, Inc., 1998.

Hetherington, Alma. *The River of the Long Water.* Chuluota, FL: The Mickler House Publishers, 1980.

Hoover, J. Edgar. *Persons in Hiding.* Boston, MA: Little, Brown and Company, 1938.

Johnston, James A. *Alcatraz Island Prison and the Men Who Live There.* New York: Charles Scribner's Sons, 1949.

Karpis, Alvin, and Bill Trent. *The Alvin Karpis Story.* New York: Coward, McCann and Geoghegan, Inc., 1971.

Keve, Paul. *Prisons and the American Conscience: A History of Federal Corrections.* Carbondale and Edwardsville: Southern Illinois University Press, 1991.

Louderback, Lew. *The Bad Ones.* Greenwich, CT: Fawcett Publications, Inc., 1968.

McElvaine, Robert S. *The Great Depression.* New York: Three Rivers Press, 1993.

Needham, Ted, and Howard Needham. *Alcatraz.* Millbrae, CA: Celestial Arts, 1976.

Oliver, Marilyn T. *Alcatraz Prison in American History.* Berkeley Heights, NJ: Enslow Publishers, Inc., 1998.

Opdyke, John, ed. *Alachua County A Sesquicentennial Tribute*. Gainesville, FL: Alachua County Historical Commission, 1974.

Orange County Sheriff's Office, Orlando, Florida, *150ᵗʰ Anniversary History Book*. Paducah, KY: Turner Publishing Company, 1994. (coordinated by Corporal Doug Sarubbi; created, coordinated and designed by David A. Hurst)

Powers, Richard Gid. *G-Men; Hoover's FBI in American Popular Culture*. Carbondale and Edwardsville: Southern Illinois University Press, 1983.

Purvis, Melvin. *American Agent*. Garden City, NY: Doubleday, Doran and Company, Inc., 1936.

Rogers, William W. "Fortune and Misfortune: The Paradoxical Twenties." In *The New History of Florida*, edited by Michael Gannon. Gainesville: University Press of Florida, 1996.

Rogers, William W. "The Great Depression." In *The New History of Florida*, edited by Michael Gannon. Gainesville: University Press of Florida, 1996.

Rogers, William Warren, and James M. Denham. *Florida Sheriffs: A History 1821–1945*. Tallahassee, FL: Sentry Press, 2001.

Sterling, William Warren. *Trails and Trials of a Texas Ranger*. Norman: University of Oklahoma Press, 1959.

Stuller, Jay. "There was never a harder place than 'the Rock.'" *Smithsonian Magazine* 26, September 1995.

Tebeau, Charlton, and Marina William. *A History of Florida*. Coral Gables, FL: University of Miami Press, 1999.

Tolland, John. *The Dillinger Days*. New York: Random House, 1963.

Vickers, Raymond B. *Panic in Paradise*. Tuscaloosa: University of Alabama Press, 1994.

Weigall, T.H. *Boom in Paradise*. New York: Alfred H. King, 1932.

Whitehead, Don. *The FBI Story*. New York: Random House, 1956.

NEWSPAPERS

Florida Times-Union
Houston Post
Houston Press
Mulberry Press
Orlando Evening Reporter Star
Orlando Reporter Star
Orlando Morning Sentinel

Polk County Record
Sumter County Times
Tallahassee Daily Democrat
Tampa Daily Times
Tampa Morning Tribune
Tampa Sunday Tribune
Tampa Times
Tampa Tribune
Tampa Tribune-Times

MAGAZINES

Hoyt, Jay. "Double for Trouble." *True Detective Mysteries*, August 1940.
Mayers, L.L. "Texas The Heat Is On!" *American Detective Fact Cases*, April 1938.

PRIMARY/GOVERNMENT DOCUMENTS

Admission Summary Classification Form 1 Hugh Gant.
Atlantic Coast Line Railroad Company Police Department notice 3-1750-1-2-3-4.
D.C. Form No. 14 Commitment, Criminal Case 9631 Hugh Gant.
FBI: Facts and Figures, September 1996 edition.
FBI notice to all law enforcement officers in Alabama, 91-37, dated October 2, 1937.
FBI notice to all law enforcement officers in Alabama, 91-37, dated October 5, 1937.
Federal Bureau of Investigation, case summary I.C. #91-493.
Federal Bureau of Prisons Inmate File for Hugh Archer Gant.
Fingerprint Identification, Department of Justice, Federal Bureau of Investigation.
Florida State Archive Original Register 1921–1927.
Florida State Archive Prison Sentence List.
Hillsborough County Criminal Court Case # 2140.
National Archives and Records Administration, Central Plains Region—Report on Hugh Archer Gant/Leavenworth.
National Archives and Records Administration, West Region—Report on Hugh Archer Gant/Alcatraz.
Orange County Circuit Court Case #9832.

Parole Report Form #2, Hugh Gant Miami, FL, File No. 91-21.
Post Office Department Reward poster #51757-D.
Prison Register Book 2, "B", Series 500.
Prison Register Book 3, "C", Series 500.
Record of Soldiers, Discharge Record, World War I, Sumter County.
Record of Soldiers, World War I, 1917–1919, Sumter County.
Registration card National Archives SE Region for AD Hunt.
State of Florida marriage license Charles Hugh Smith and Audie Lee Cotton.
State of Florida marriage license H.A. Gant and Ida Burke.
State of Florida Office of Vital Statistics marriage licenses.
Sumter County Marriage Record book #5.
Sumter County Marriage Record book #6.
U.S. Department of Justice Identification CR Form #61, Case 665.
U.S. Department of Justice Identification Order #1358 (wanted poster).
U.S. Department of Justice Identification Order #1399 (wanted poster).
Wanted poster 3-1447 Gant and Hunt.

INTERVIEWS

Hunt, Ann. Phone interview. September 24, 2004.
Hunt, Betty. Phone interview. September 24, 2004.
Hunt, Buddy. Phone interview. September 24, 2004.
Hunt, Mrs. Douglas K. Phone interview. September 24, 2004.
Hunt, Mrs. Douglas, and Rhonda Hunt (daughter-in-law). Personal interview. October 15, 2004.
Hunt, Rhonda. Personal interview. November 10, 2004.
Hunt, Ronald. Phone interview. October 12, 2004.
Hunt, Ronald. Personal interview. October 15, 2004.
Hunt, "Sonny" Alva. Phone interview. September 25, 2004.
McMillan, Inez. Phone interview. October 19, 2004.
Williams, Deputy Edwin. Phone interview. November 10, 2004.
Wing, Bill. Personal interview. June, 6, 2003.

MUSEUMS

Historic Museum of St. Cloud and Osceola County
Mulberry Phosphate Museum
Orlando Regional History Center
Polk County Historical Museum

visit us at
www.historypress.net